THE BEST OF SKETCHING AND DRAWING

QUARRY

First published in the United States of America by:
Quarry Books, an imprint of
Rockport Publishers, Inc.
33 Commercial Street
Gloucester, Massachusetts 01930-5089
Telephone: (978) 282-9590
Fax: (978) 283-2742

Distributed to the book trade and art trade in the United States by:
North Light, an imprint of
F & W Publications
1507 Dana Avenue
Cincinnati, Ohio 45207
Telephone: (800) 289-0963

Other Distribution by:
Rockport Publishers, Inc.
Gloucester, Massachusetts 01930-5089

ISBN 1-56496-510-4

10 9 8 7 6 5 4 3 2 1

Design: Sawyer Design Associates, Inc.
Diane Sawyer, Nina Souther, Amy Weiss

Front Cover: *Male Torso,* Dan Gheno, p. 25
Back Cover: *Breathless,* Stephen Fisher, p. 33
 Study for Pressure, Robert Longo, p. 123
 Return from Paris, Will Barnet, p. 81
Page 3: *Sense-Ability,* Patricia Brown, p. 72

Manufactured in China.

THE BEST OF SKETCHING AND DRAWING

A COLLECTION OF STILL LIFES, PORTRAITS AND LANDSCAPES

Selected by Terry Sullivan

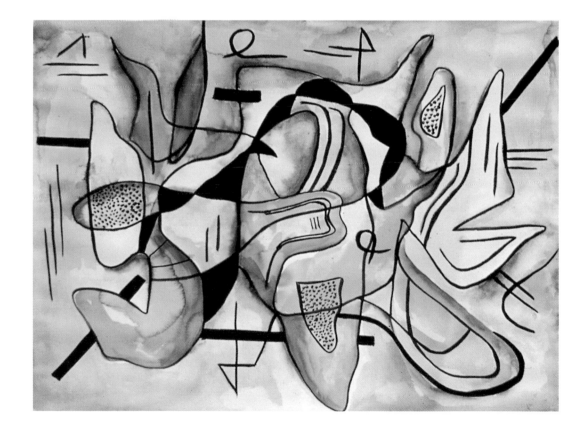

GLOUCESTER MASSACHUSETTS

QUARRY BOOKS

INTRODUCTION

*W*hen I was a boy, I took piano lessons from a wonderful teacher. I remember that in his studio he had a framed puzzle showing a reproduction of one of Beethoven's original manuscripts. Cross-outs, scribbles, and smudges filled the entire page. It seemed as though not a single notation remained uncorrected. When I mentioned to my teacher how messy the manuscript looked, he pointed out that it was perhaps Beethoven's constant reworking that makes his music so human and so moving. He said that without his uncompromising temperament and ability to edit all that is unessential, the notes would not strike such a powerful chord in us today.

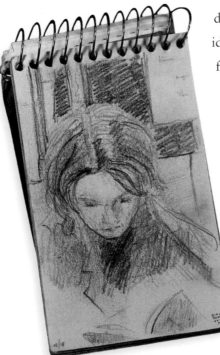

I have never forgotten my teacher's comments nor the image of the manuscript. Perhaps that's because I feel the process that Beethoven used to write his compositions is so similar to the way many of the great masters in art history used their drawings and sketches, which are often the first steps in the progression from idea to a finished painting. Many times this initial step looks dramatically different from the completed work of art. However, sketches and drawings can also point to a new direction for an artist's body of work.

In fact, sketching and drawing may have been crucial in launching two major movements in the history of art: Renaissance painting and Cubism. In the early decades of the fifteenth century, Filippo Brunelleschi (1377–1446) was the architect responsible for creating a new architectural style that moved away from the Gothic style in favor of one that

looked to classical forms and measurements. This new way of constructing buildings and cathedrals was based on Brunelleschi's investigation of ancient Roman ruins that he had studied while in Rome. It was during this time that Brunelleschi invented scientific or linear perspective in an attempt to accurately sketch the ruins of which he wished to make a visual record. (Although the artists of antiquity did understand the concept of foreshortening, it seems they had no mathematical laws to accurately depict how objects diminished with size as they receded in space.)

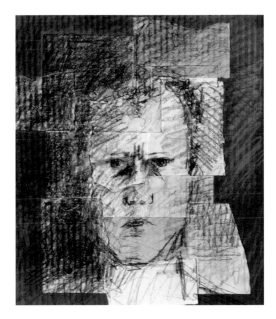

As the esteemed art historian E. H. Gombrich points out in his book, *The Story of Art*, "We remember that no classical artist could have drawn the famous avenue of trees leading back into the picture until it vanishes on the horizon. It was Brunelleschi who gave artists the mathematical means of solving this problem; and the excitement which this must have caused among his painter-friends must have been immense." It was a system that spread like wildfire in fourteenth and fifteenth century Italy—Masaccio, Uccello, Piero della Francesca, Mantegna, Raphael, Michelangelo, and Leonardo all incorporated this device into their artwork. Moreover, Brunelleschi's theories laid the groundwork for the invention of photography more than 400 years later. Consequently, it may be argued that Brunelleschi's sketches set in motion nearly 500 years of art!

Many would claim the artist Pablo Picasso (1881–1973) put an end to the dominance of Brunelleschi's perspective. How did he do it? For starters, Picasso was a copious sketcher. He scrutinized the old masters as well as contemporary artists. He looked to African artworks, people in the cafes,

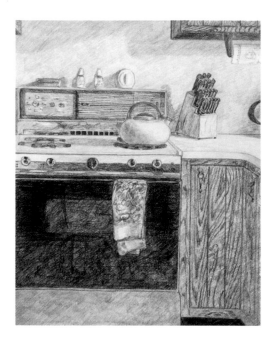

himself, his family, friends, and lovers. And he was a great lover of mass-media images—caricatures and cartoons. It was his genius as a draftsman that permeates his whole oeuvre, which in one way or another reveals all these influences.

Take his *Les Demoiselles d'Avignon,* which many claim started Picasso's Cubist style—the first style that truly has no trace of Renaissance perspective or even a suggestion of fixed space. This work started with a sketch of two men visiting a brothel, one sitting and one entering the room, surrounded by nude women. In the finished painting, Picasso chooses to only focus on the nudes and a still life, eliminating the men as well as the narrative aspect of the sketch. The setting is transformed from a specific place—a brothel—in the drawing into a more universal and ambiguous space. Moreover, although the painting includes five distorted versions of classical nudes (from

the old masters), Picasso depicts three of the five women's faces as African masks, revealing his interest in both classical nudes and African art forms. One could even say he was caricaturing some of the nudes. However, one thing is certain: By starting out with a sketch, Picasso was able to take

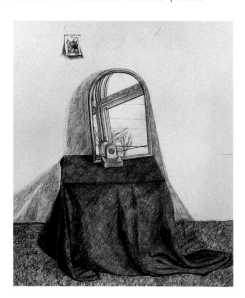

more chances and experiment more readily when he decided to pick up his paint brush and set paint to canvas. It's a process that Picasso would repeat throughout his career. Like scientific perspective, the invention of Cubism inspired some of the most well-known artists of the twentieth century: Henri Matisse, Piet Mondrian, Arshile Gorky, Jackson Pollack, Willem De Koonig, David Hockney, and Elizabeth Murray.

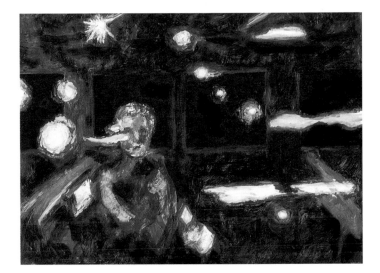

Are the sketches of two artists responsible for 600 years of art? Perhaps not. However, the colossal achievements of Brunelleschi and Picasso underscore the importance of the activity of drawing and sketching.

The artists included in this book understand the importance of drawing. That's why they have been included in this book. They work in a variety of styles and with a variety of subject matter, and their sketches reflect this. Some create detailed, finished drawings, while others use gestural lines and quick notations to sum up a thought or idea. Some have been working for decades, others just for a few years. But what all of these artists have in common is a passion for the medium of sketching and drawing and an unquenchable thirst for new forms and new ideas. I hope you enjoy this collection as much as I have enjoyed selecting the works.

—*Terry Sullivan*

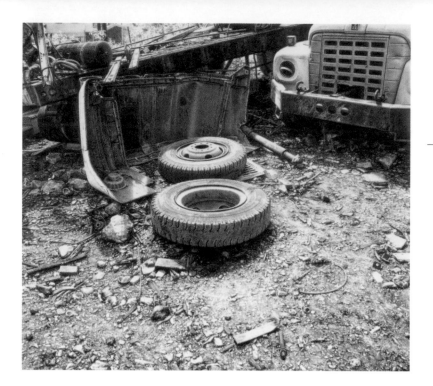

JAY KELLY

Two Tires—Doremus Avenue, Newark NJ
8" × 9" (20 cm × 23 cm)
Graphite on paper

Kelly's drawings generate a sense of
tension by depicting industrial landscapes
that include rusted garbage cans and old
automobile tires in a meticulous, objective
manner.

ROBERT GIRANDOLA

Untitled
18" × 16" (46 cm × 41 cm)
Charcoal on primed paper

By not completely erasing the preliminary
sketch marks, Girandola lets the viewer
take part in how the artist rendered the
figure in this drawing. Faint charcoal lines
in a work are often called ghost marks.

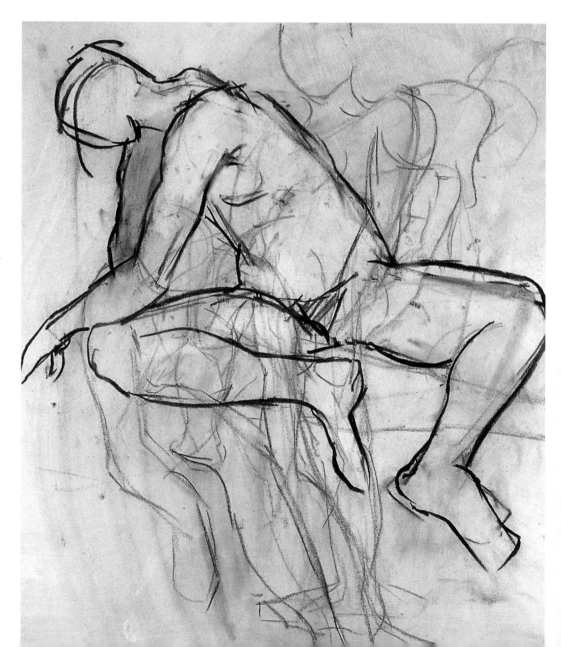

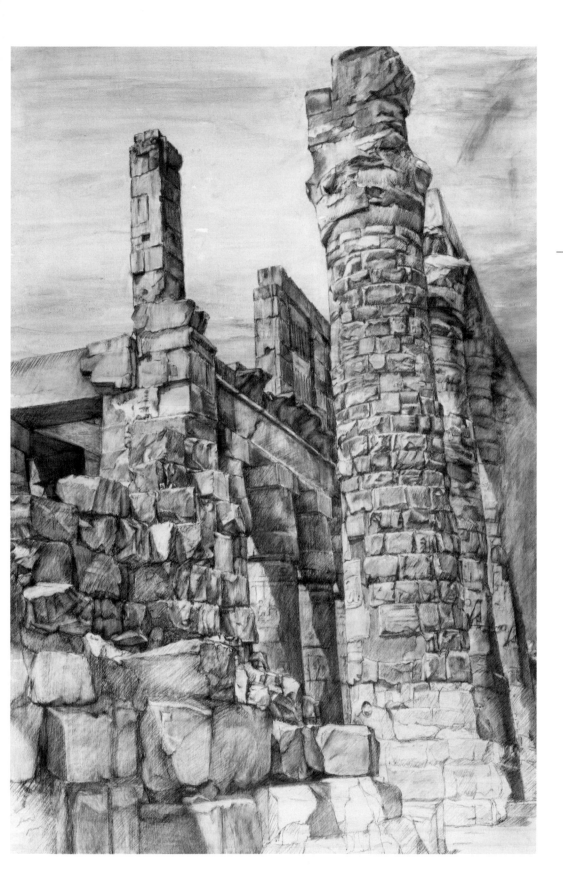

JANE SUTHERLAND

Egypt I

56" × 36" (142 cm × 91 cm)

Charcoal, pastel, and pumice gel on paper

Sutherland coats the paper with fine pumice gel. Next, she grinds charcoal and burnt sienna pastel together to produce a powder, which is used to tone the surface. The main linear elements were created with charcoal and heightened with white. Sutherland left the bottom part of this drawing unfinished to reveal the roots of the structure.

CHRISTOPHER WILLARD

Nabe

17" × 22" (43 cm × 56 cm)

Pen and ink on grid paper

The grid serves as an armature on which the artist works out his carefully designed drawing.

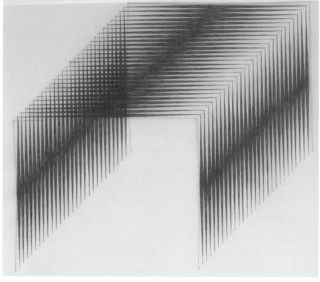

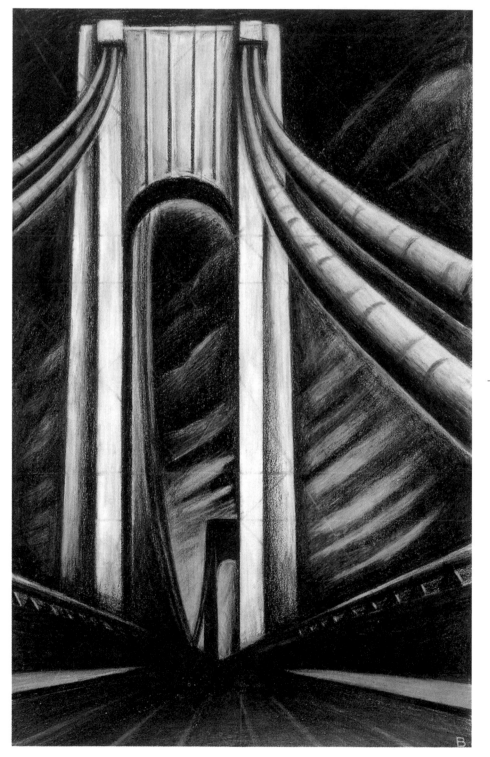

BASCOVE

Verrazano-Narrows Bridge

16" × 10" (41 cm × 25 cm)

Colored pencil on vellum

Bascove begins all her paintings with a grid intersected with diagonal lines. Quite often, this grid incorporates the golden section—a proportion resulting from the division of a straight line into two parts so that the ratio of the whole to the larger part is the same as that of the larger to the smaller. This ratio turns out to be approximately 1:1.62. By basing her forms on this ancient proportion, the artist can achieve a harmony and balance in her work.

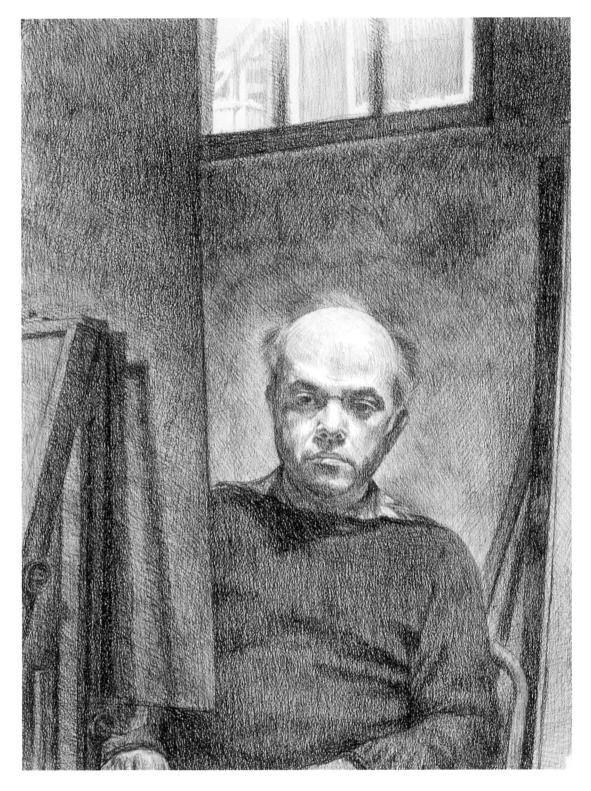

DOMENIC CRETARA

Self-portrait
32" × 20" (81 cm × 51 cm)
Charcoal pencil on paper

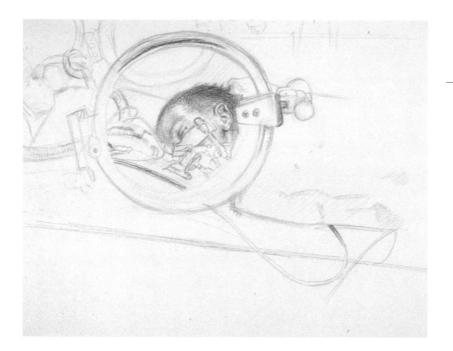

SIGMUND ABELES

Max in Intensive Care

9" × 12" (23 cm × 30 cm)

Graphite on paper

This is one of a series of heartfelt drawings of the artist's son, who was born prematurely. "Drawing is touching at a distance," the artist says. "It is one of the most vital connections I have to life, a lifeline."

JAMES P. TEMPLETON

Palladio's Villa Rotunda

11⅝" × 8¼" (29.5 cm × 21 cm)

Pen and ink on 150 gm/m² sketchbook paper

Templeton's sketches of this famous Italian Renaissance building depict the structure from three different viewpoints—head on (bottom), floor plan (middle), and viewed at an angle. In doing so, the artist has made intimate the logical and harmonious structure that is the key to this architectural masterpiece.

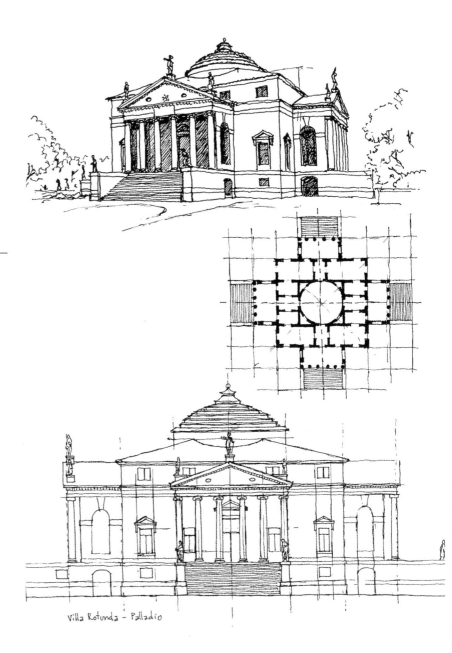

Villa Rotunda - Palladio

T. F. INSALACO

Study for the Dedication Triptych
25" × 19" (64 cm × 48 cm)

Charcoal on white Stonehenge paper

Insalaco used compressed charcoal to create very dark values in the shirt and pants, which contrast with the subtly blended areas of the flesh and the untouched, negative spaces between the stool and the figure's legs. "I selectively cropped the image to enhance the sense of drama and personal turmoil," says the artist.

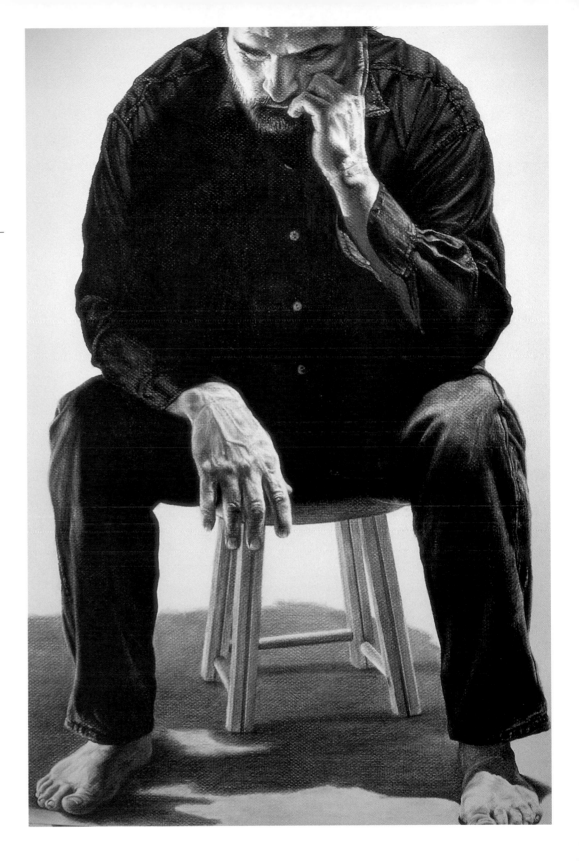

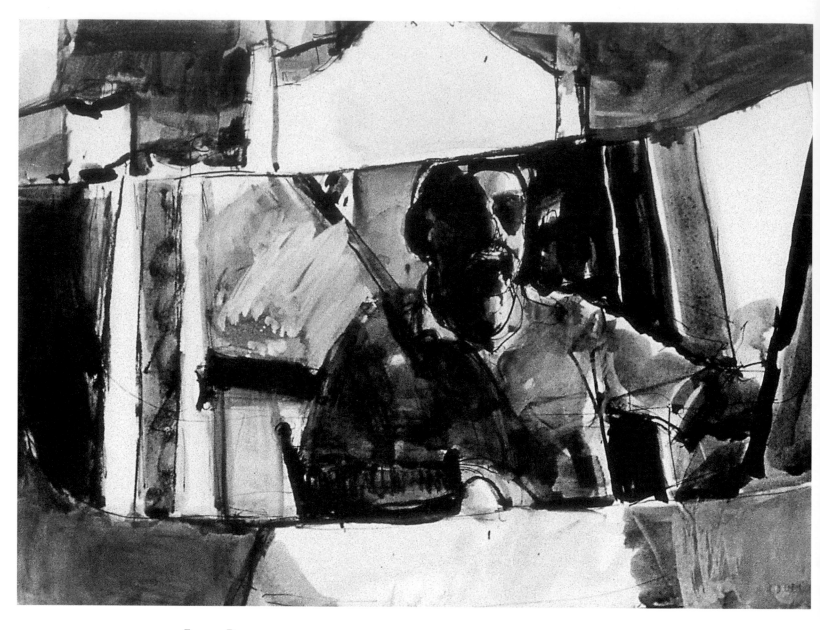

EDWIN DOUGLAS

Window Reflections
11" × 15" (28 cm × 38 cm)
Charcoal, wash, gouache on rag paper

BETTY M. BOWES

Anna

12" × 9" (30 cm × 23 cm)

Pencil on paper

Bowes conveys the girth and weight of this figure with a delicate contour line.

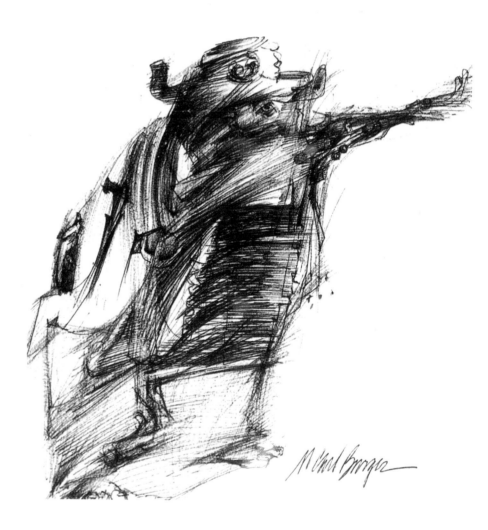

W. CARL BURGER

The Orator

12½" × 8½" (32 cm × 22 cm)

Pen and ink on illustration board

Burger says that this image started out as an exercise in diagonals and gradually turned into a caricature. As the title suggests, the drawing pokes fun at people who lecture on subjects they don't know about.

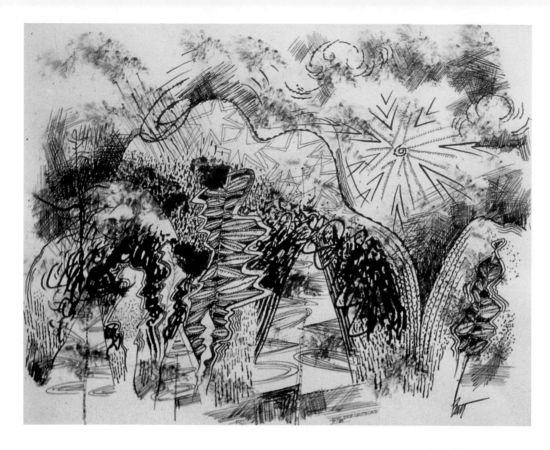

MILES G. BATT

Nine-Tree Landscape

10½" × 13" (27 cm × 33 cm)

India ink and pens on plate bristol board

In order to emphasize the sense of movement in this sketch, Batt uses a variety of techniques, such as stippling, hatching, cross-hatching, and broken lines.

MARYBETH HEIKES

Back Alley Series #9

7" × 11" (18 cm × 28 cm)

Pencil on Stonehenge drawing paper

With a nod to the Precisionist school of artists in the first half of this century, who focused on the geometry and structure of the city landscape, Heikes has chosen to create a series of drawings based on back alleys. In this landlocked, industrial setting, the artist adds a bit of irony by including the letters *SEA* on a garage door at the far end of the alley.

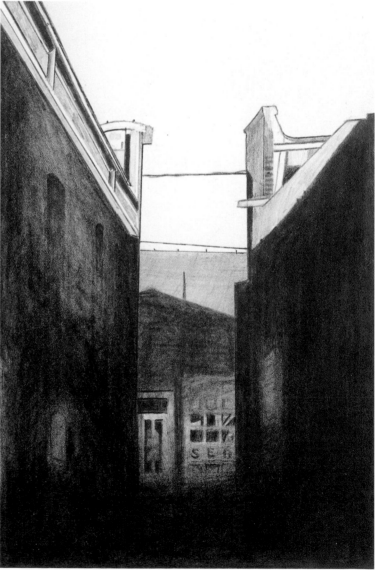

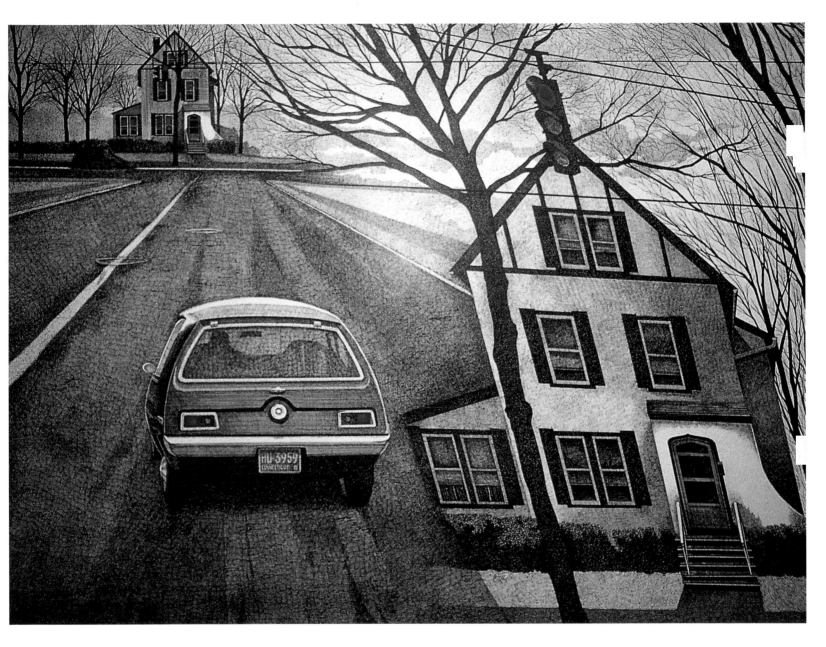

JOSEPH J. CORREALE JR.

Déja Vu at the Light

40" × 50" (102 cm × 127 cm)

Pen and ink on illustration board

Through repetition of forms—in this case the house, the traffic light, and the trees—the artist has attempted to visually evoke the feeling of déja vu.

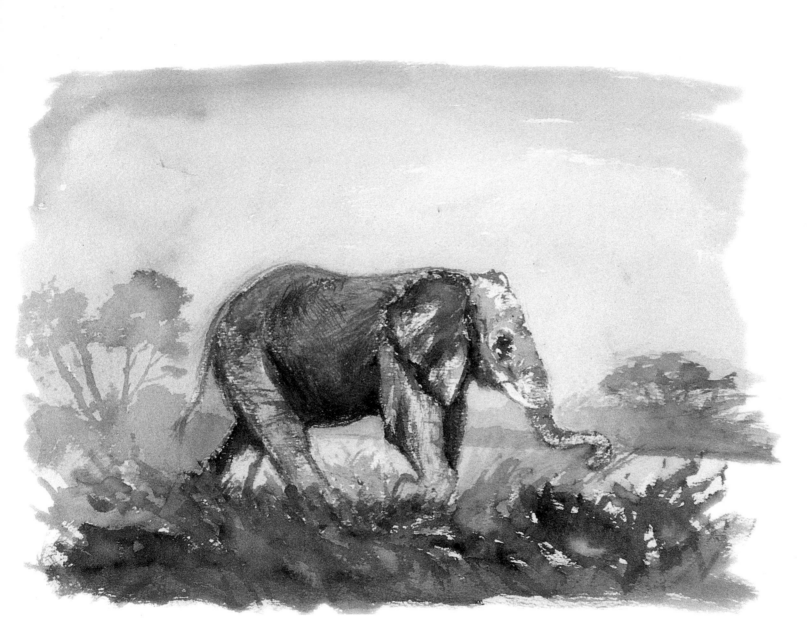

DONALD RESNICK

Lone Bull
10¾" × 14¾" (27 cm × 37.5 cm)
Ink on paper

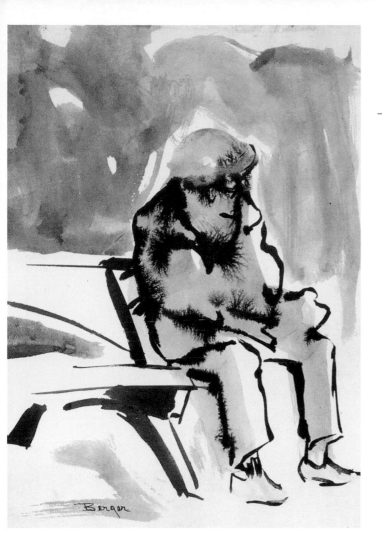

PAT BERGER

Old Man

11" × 8¹/₂" (28 cm × 20.5 cm)

Ink wash on paper

Berger achieves a wonderful quality in this sketch by letting some of the lines she creates with her brush bleed into the background ink wash.

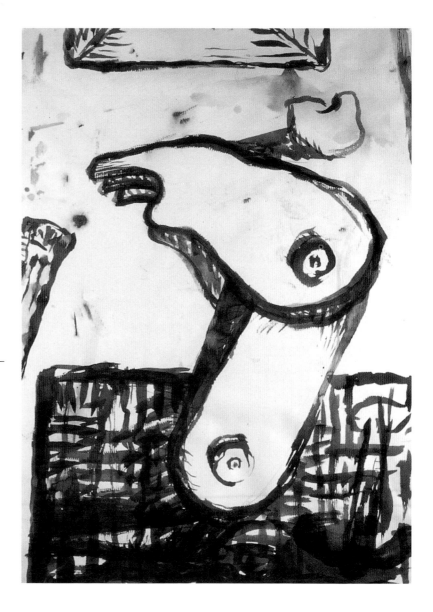

WILLIAM LEWIS

Untitled

27" × 19" (68 cm × 48 cm)

Sepia ink on paper

There is an ambiguity in how the artist uses the forms in this drawing. The viewer is not sure whether the forms are representational images of mechanical objects or purely abstract forms. The tension that results is essential to the essence of the picture.

John J. de Soto

4 PM Sitting Position

16" × 16" (41 cm × 41 cm)

Pencil on illustration board

The artist uses a 2H and 4B pencil to create a variety of tones. He also scrapes the surface with sandpaper to create texture.

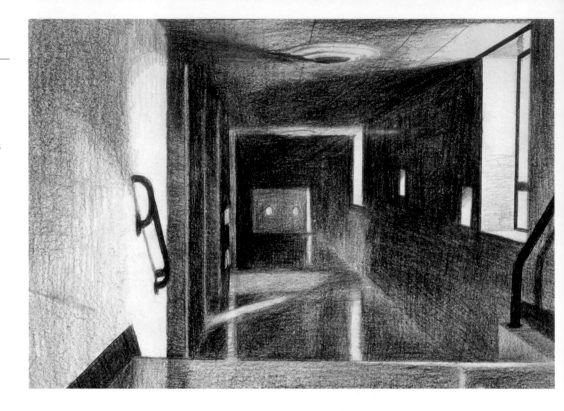

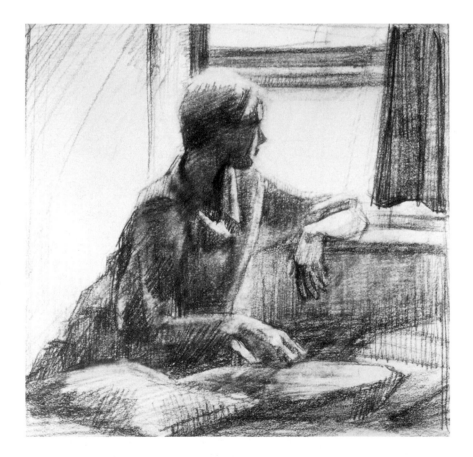

Cynthia Grilli

Study for Daydream

6" × 6" (15 cm × 15 cm)

Pencil on paper

Kyle Lind

Wheel of Life

16" × 14" (41 cm × 36 cm)

Pen and ink on illustration board

Organic forms rendered painstakingly in meticulous hatch marks comprise this intricate drawing. Although it is an entirely abstract work, the longer you look at the work, the more you begin to imagine shapes. It's a phenomenon that dates back at least as far as Leonardo da Vinci's deluge chalk drawings, which Lind's work resembles.

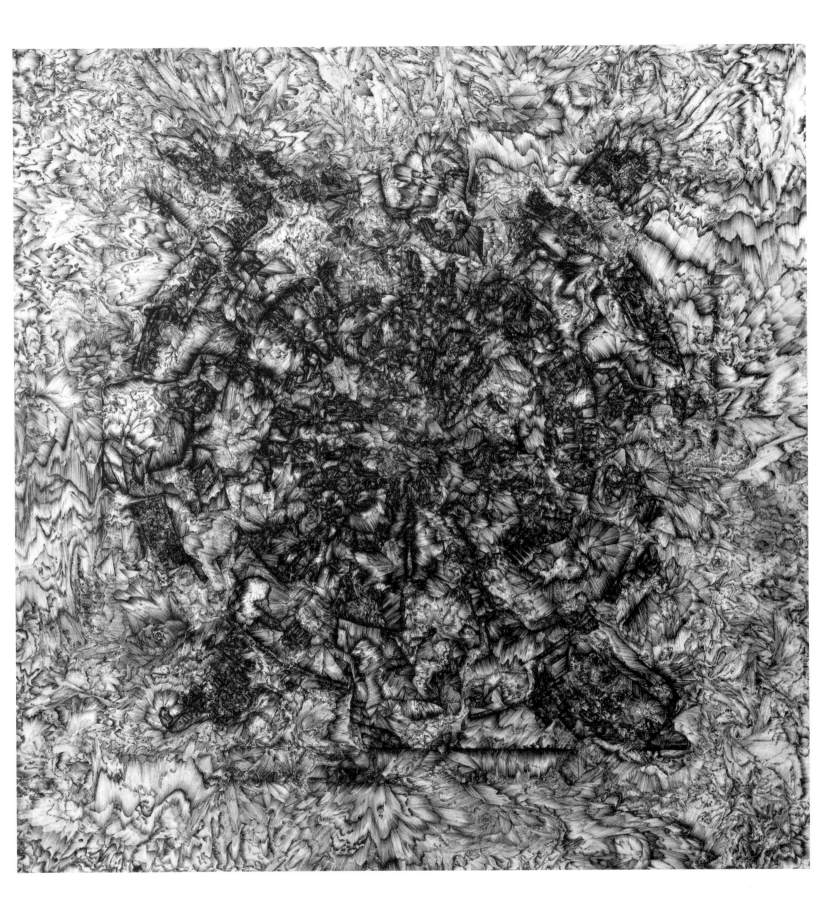

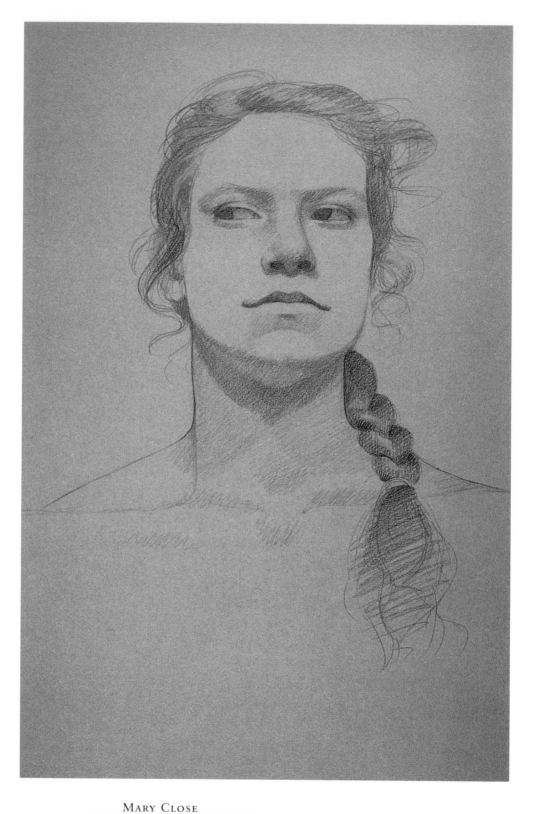

MARY CLOSE

Girl with a Braid

17" × 12¼" (43 cm × 30.5 cm)

Pencil on paper

BRAD FAEGRE

Ironing

14" × 17" (36 cm × 43 cm)

Pen and ink on 60-lb. drawing paper

Faegre depicts a common, slice-of-life scene using quick pen strokes. The hanging shirt that is draped over the ironing board contrasts with the rigid, upright iron. One gets the sense that the iron is ready to pounce on the shirt.

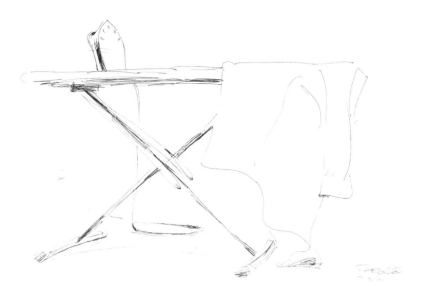

JUDY ANDERSON

She Has a Checkered Past

10" × 8" (25 cm × 20 cm)

Ink and ink wash on wood

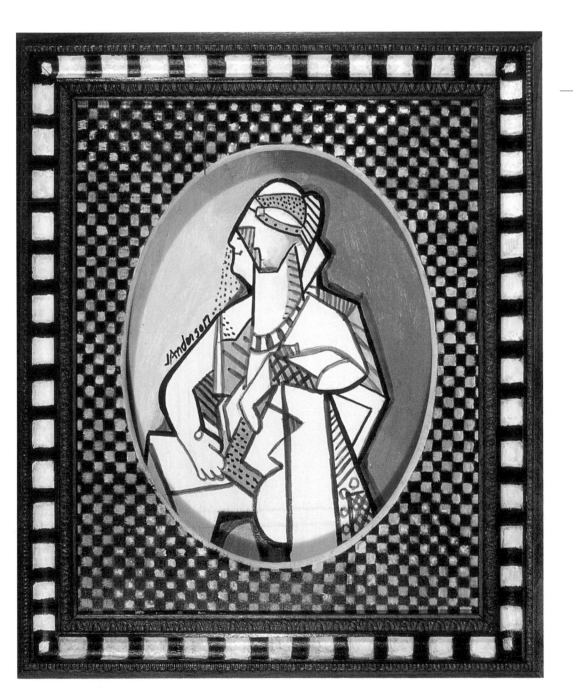

R. Schofield

Light of Time

6" × 8" (15 cm × 20 cm)

Colored pencil on paper

Using a stippling method—a slow accumulation of dots to create form and tone—the artist has rendered a puzzling, contradictory landscape made up of geometric forms and mysterious shadows.

Fleur Byers

November Morning

16¹/₂" × 23" (42 cm × 58 cm)

Charcoal on Canson paper

The artist has dramatically cropped the figure's head and shoulders out of the composition while at the same time including the figure's entire shadow. This last element not only adds an abstract quality to the composition but gives the viewer a sense of time, as mentioned in the title of the drawing.

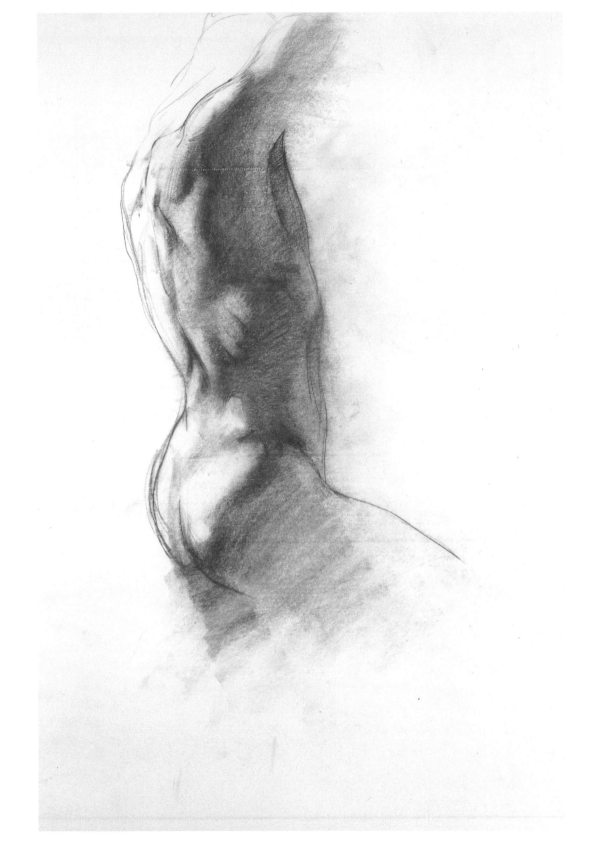

DAN GHENO

Male Torso
24" × 18" (61 cm × 46 cm)
Sanguine on bond paper

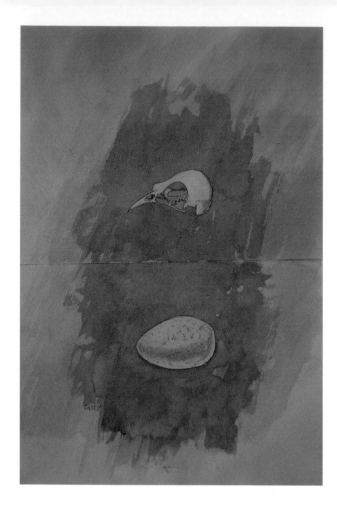

JOHN T. CASEY

Alpha and Omega

10" × 8" (25 cm × 20 cm)

Pen and ink, wash, and white conté
on paper

Casey presents two forms—a bird egg
and bird skull—on two pieces of paper
that have been joined. By placing these
objects on either side of the visible edge
of where the two pages meet, he has
made the edge an integral part of the
composition, infusing it with symbolic
power.

WARREN TAYLOR

Gentle Island

45" × 68" (114 cm × 173 cm)

Charcoal and conté on Whitehead
drawing paper

The artist achieves a wonderful
chiaroscuro by employing the wipe-out
or pull-off technique. This technique
requires the artist to erase some of the
charcoal in order to bring back the light
tones and highlights.

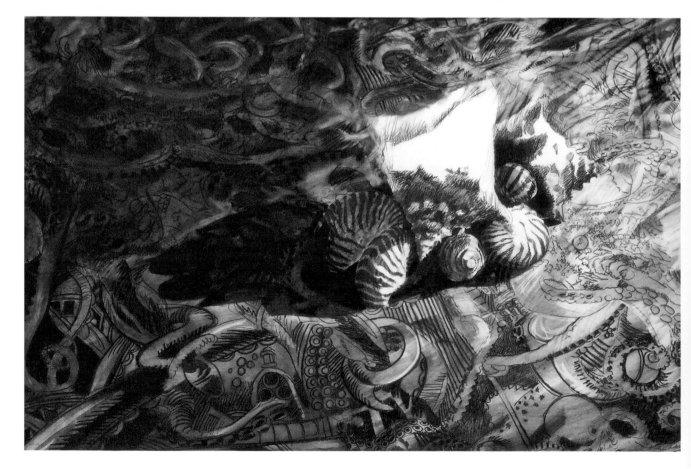

DOUGLAS DIBBLE

Untitled

17¹/₂" × 21" (44 cm × 53 cm)

Charcoal, ink, and gesso on paper

Dibble repeats the image of feet twice, creating an echo effect in the work.

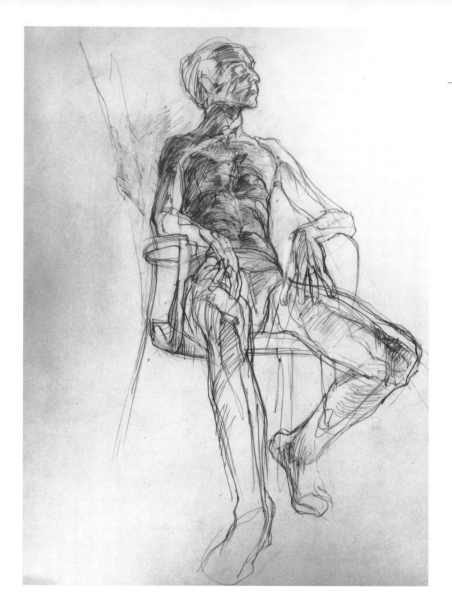

ALEX McKIBBIN

Drawing from Life

24" × 18" (60 cm × 46 cm)

Charcoal pencil on paper

McKibbin uses gestural lines to depict the form and tone of the figure. Because of his viewpoint, he has exaggerated the size of the figure's legs, making them out of proportion to the rest of the body.

NANCY OHANIAN

Saul Bellow

7" × 5¹⁄₂" (18 cm × 14 cm)

Pen and ink on smooth bristol board

Ohanian, whose pen-and-ink drawings frequently appear in the *Los Angeles Times'* opinion-editorial section as well as in other newspapers, builds up the tone and form of this famous novelist's face by means of tightly controlled hatching and cross-hatching.

LOIS I. RYDER

Race Point, Cape Cod

14" × 22" (36 cm × 56 cm)

Scratchboard

This work was created on a scratchboard, which is a white board covered with a coat of black ink. The artist used a stylist to scrape away the ink and create her drawing.

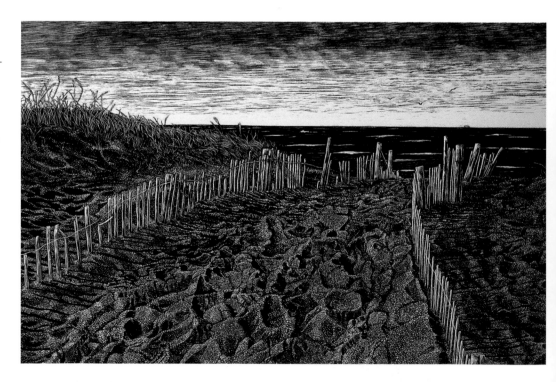

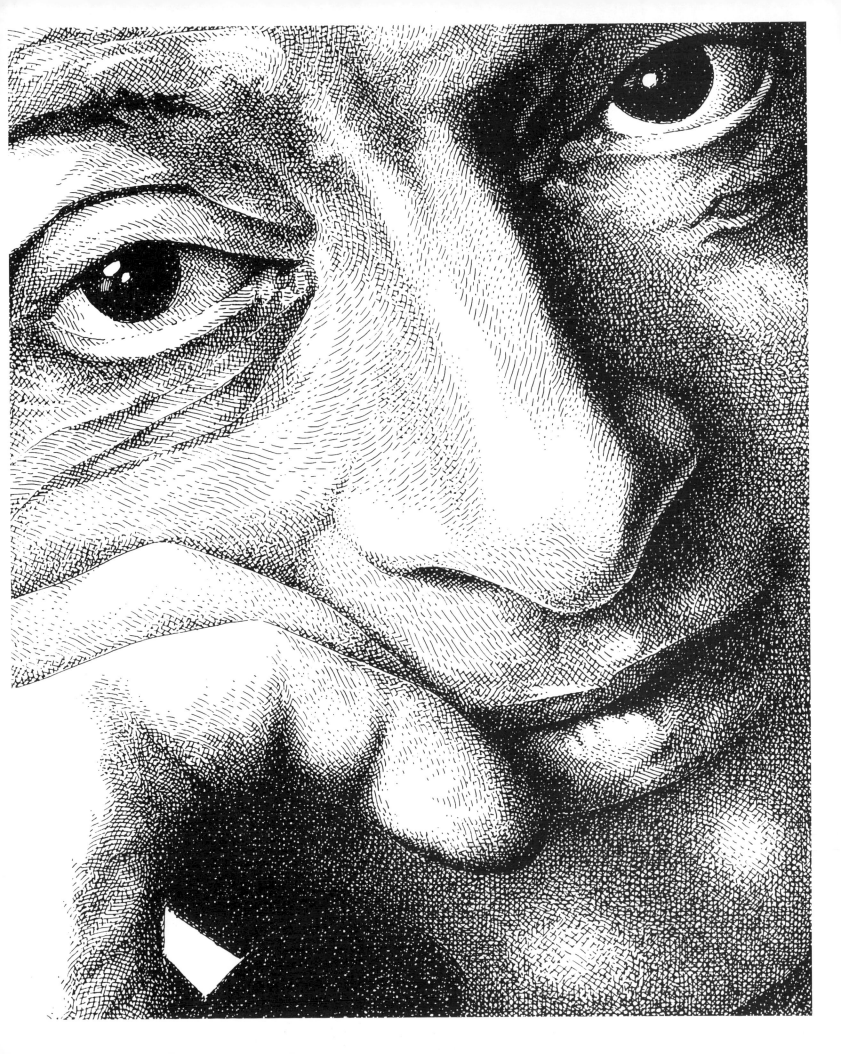

PORTER A. LEWIS

Soaring Kites

13³/₄" × 11" (35 cm × 28 cm)

Pencil on paper

This drawing is part of an ongoing series on kites.

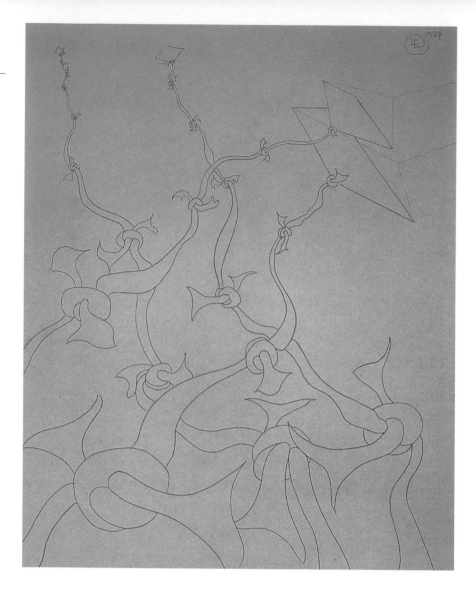

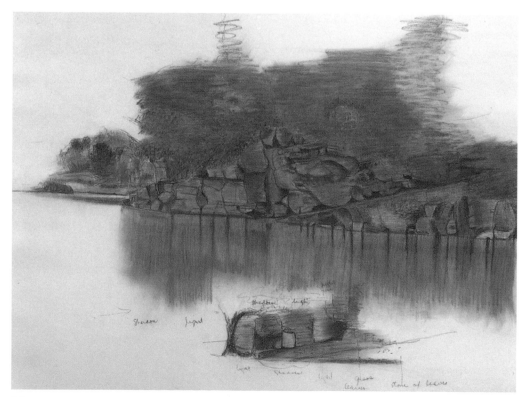

JILL MACKIE

The Narrows

18" × 24" (46 cm × 61 cm)

Conté on paper

The words (leaves, light, and grass) included on the bottom of this drawing indicate that it is a working drawing, meaning that it is not only an aesthetic object but a useful tool that provides valuable information to the artist when she decides to make a painting. In this piece, Mackie is working in a similar manner to Edward Hopper, whose drawings often included words to describe the color or tone of an object.

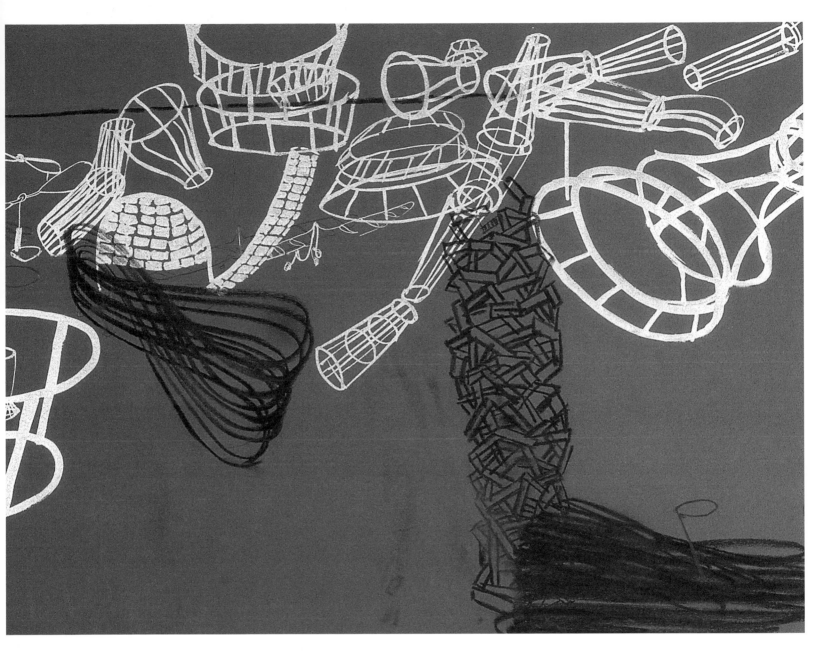

KIRSTEN WESTPHAL

Untitled

22" × 30" (56 cm × 76 cm)
Silver ink and charcoal on green paper

By using a colored ground, the artist is able to work in both lighter and darker drawing mediums. In this work, the abstract forms drawn in silver ink seem to float and come toward the viewer while the black forms rendered in charcoal seem to recede into the space.

PAUL W. McCORMACK

Carey

27" × 17" (69 cm × 43 cm)

Pencil on Strathmore four-ply bristol vellum

The artist brushes-on powdered graphite mixed with denatured alcohol to create a ground. He then proceeds to work in pencil over this ground.

ATANAS KARPELES

Life After Life

14" × 11" (36 cm × 28 cm)

Pencil on 100-lb. bristol board

This complex, fantastic scene seems to burst with energy, so much that it actually breaks through the black border on three sides. This pictorial device dates back to the illuminated manuscripts of the Middle Ages.

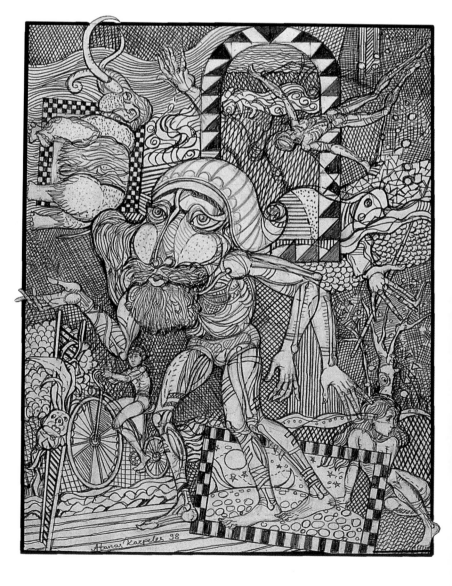

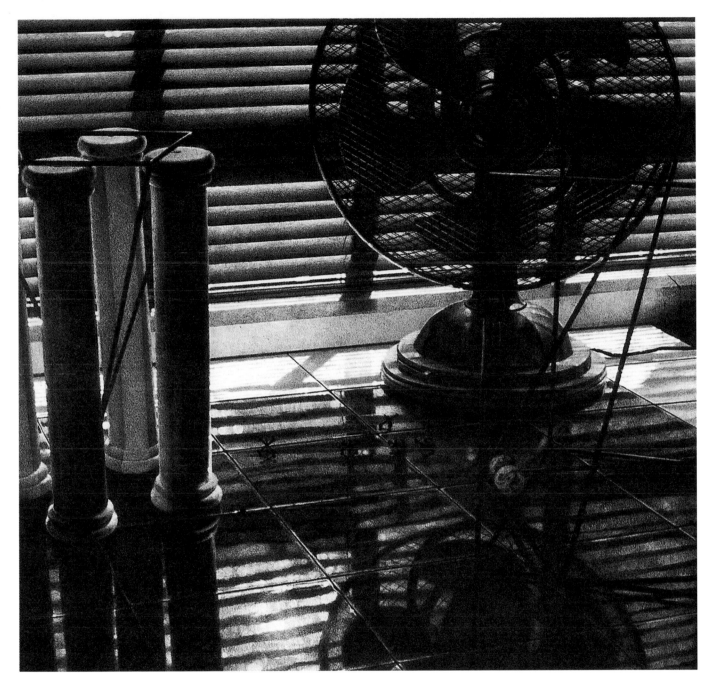

STEPHEN FISHER

Breathless

21" × 22" (53 cm × 56 cm)

Charcoal and pencil on hot-pressed watercolor paper

Grids layered over grids make up the composition of this work. The dominance of straight lines combined with high contrast of light and dark (there is almost no middle tone in the work) creates a rigid, formal composition.

ALEXANDER C. PICCIRILLO

Early Self-portrait

9" × 12" (23 cm × 30 cm)

Pencil on paper

Self-portraiture can be one of the most revealing genres. In this work, the artist confronts himself with an objective, searching, slightly weary gaze.

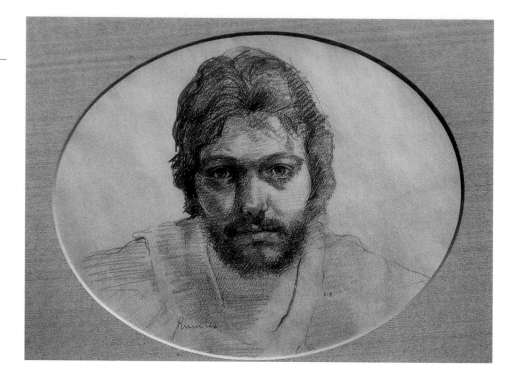

MICHAEL EDWARD CELLAN

El Pueblo Archeological Dig

24" × 18" (61 cm × 46 cm)

Pencil on white drawing paper

The thin, white lines create a grid that allows the viewer's eye to separate the picture into various sections, yet these same grids act to unify the composition.

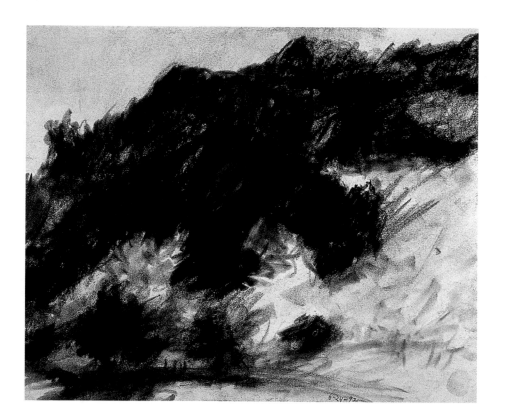

PATRICK O'KIERSEY

Park Hills

14" × 17" (36 cm × 43 cm)

Compressed charcoal on paper

The artist created this plein-air drawing using compressed charcoal and an eraser to smudge the forms.

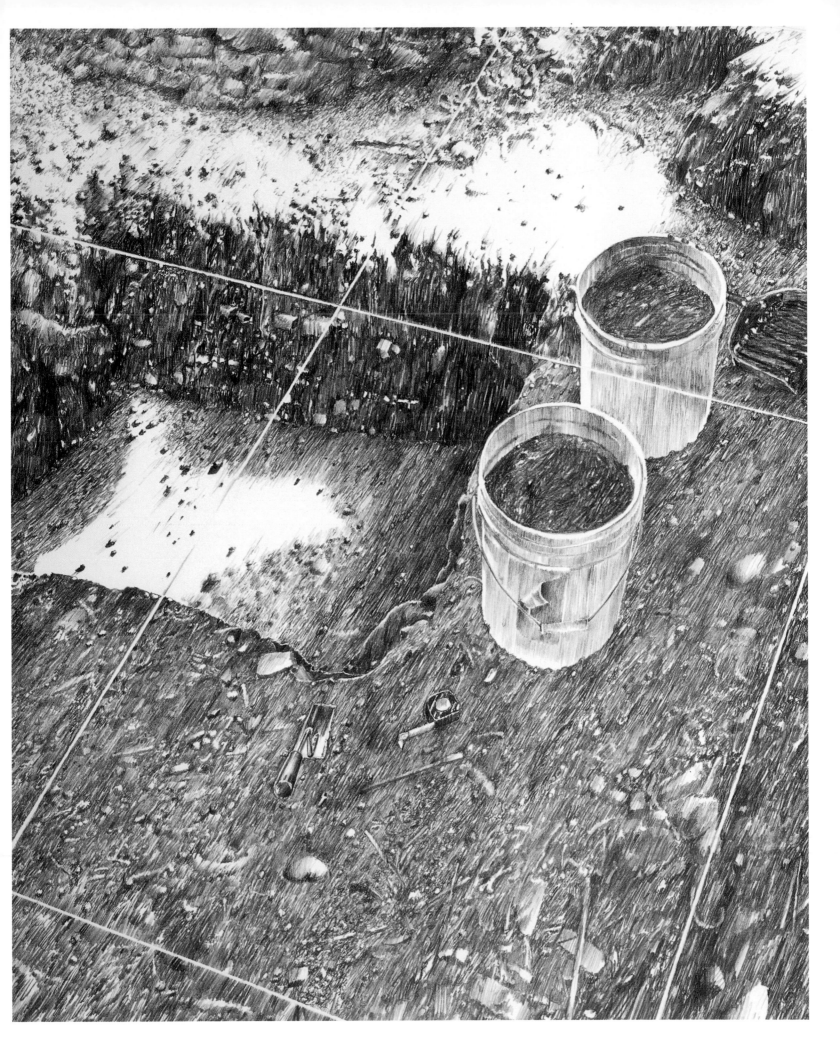

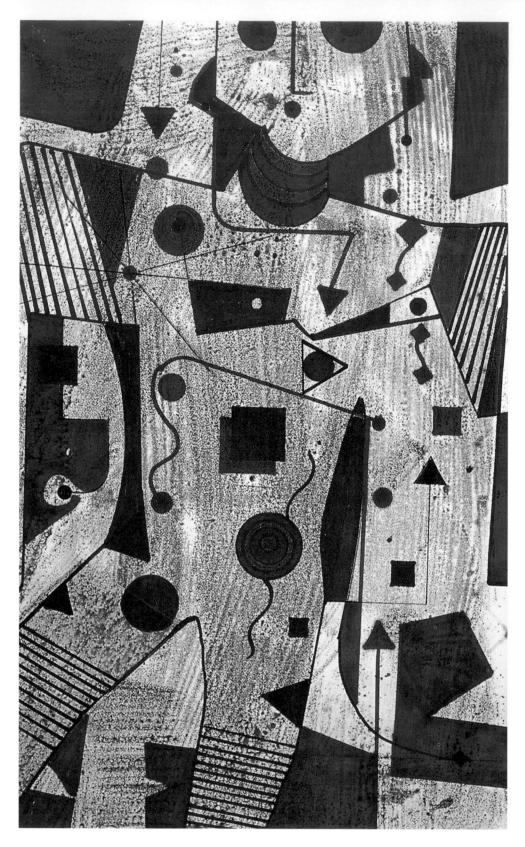

BEA JAE O'BRIEN

Bingo

12" × 10" (30 cm × 25 cm)

Pen and colored ink on drawing paper

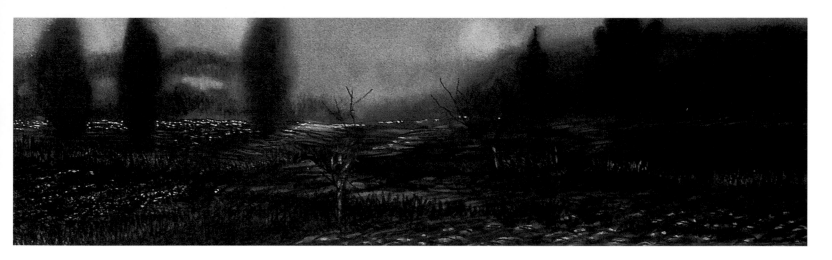

HAROLD L. GREGOR

Evening Opalescence

$8^{1}/_{2}$" × $27^{3}/_{4}$" (22 cm × 71 cm)

Compressed charcoal and white ink on 140-lb. D'Arches hot-pressed paper

Powdered charcoal was dusted on, rubbed, and erased in areas. The artist then used compressed charcoal to draw over this ground, and used white ink to add highlights.

MARGE CHAVOOSHIAN

Untitled

40" × 50" (102 cm × 127 cm)
Pen and ink on illustration board

This drawing was created by drawing a series of consecutive lines across the page, from right to left. In doing so, the artist has been able to generate a sense of landscape through the use of purely abstract elements.

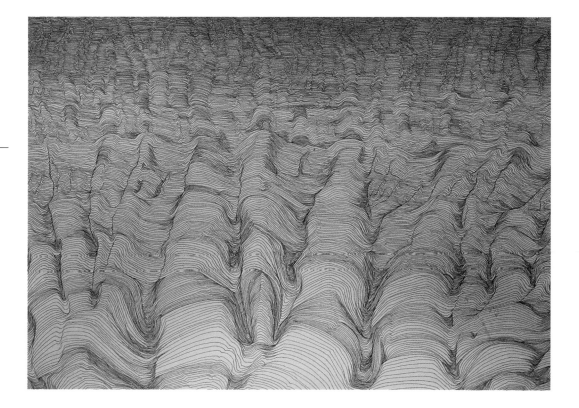

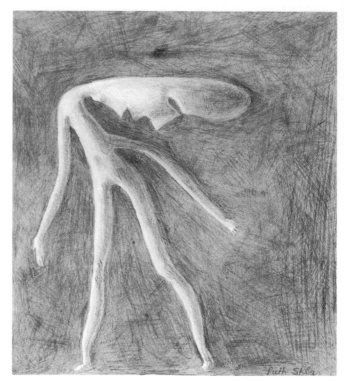

RUTH SKLAR

The Sky is Falling

$9^{1}/_{2}$" × $8^{1}/_{2}$" (24 cm × 22 cm)

Pencil on Strathmore two-ply bristol

Sklar used this unusual image of a figure to express the devastation she felt at the loss of her husband.

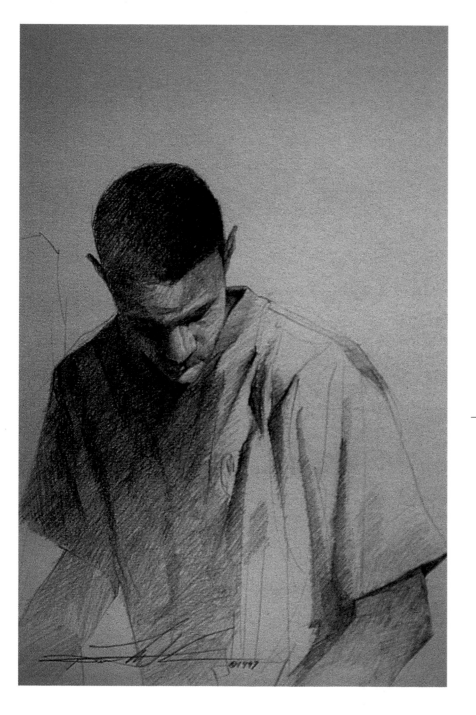

DEAN MITCHELL

Searching

10" × 8" (25 cm × 20 cm)

Pencil on paper

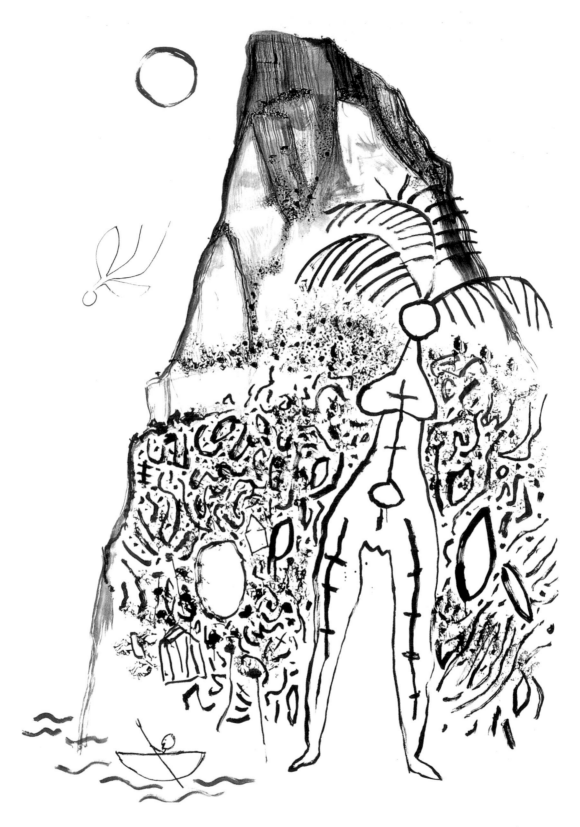

GUY WARREN

The Fall of Icarus (with Tree-Fern Woman)

120" × 79" (305 cm × 201 cm)

Ink on canvas

To help him tell the story of this ancient-Greek myth, the artist uses a type of mark-making technique that might appear in a prehistoric painting.

Norman Neasom

Hollow Men III

10" × 10" (25 cm × 25 cm)

Pencil on paper

The artist set out in this work to create a parody of human life, death, and pain. Perhaps he was inspired by the lines "Shape without form, shade without colour,/ Paralysed force, gesture without motion" from T. S. Eliot's poem, "The Hollow Men."

Anne Heywood

Daddy

19" × 13" (48 cm × 33 cm)

Pencil, charcoal, and white acrylic paint on a jigsaw puzzle

By drawing a silhouetted figure on a patterned ground, the artist has set up a spatial ambiguity: The viewer is left wondering what is the positive space and what is the negative space and whether the jigsaw-puzzle pattern is in front of the shadowed figure or is part of the background.

Eudoxia Woodward

Plotting the Portrait

10½" × 15½" (27 cm × 39 cm)

Pencil on hot-pressed rag paper

This humorous drawing has a special resonance for most artists, whose work is generally judged by others not from the original works of art but from 35 mm slides.

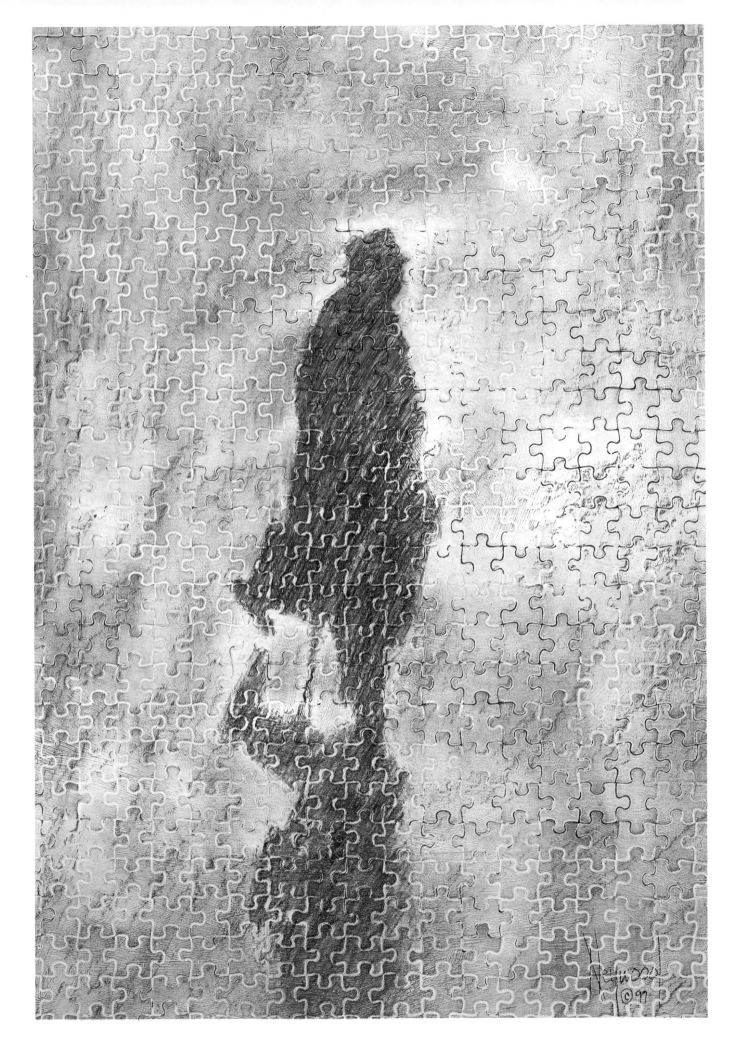

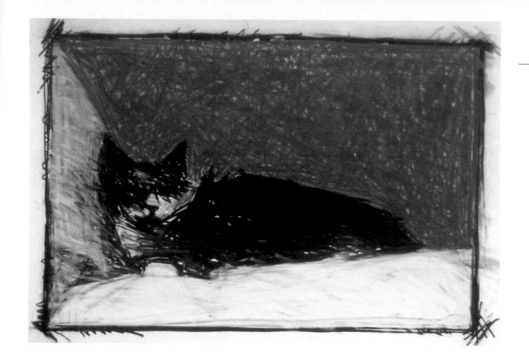

KATHERINE REAVES

Cat

11" × 16½" (28 cm × 42 cm)

Charcoal and conté crayon on paper

The layers of cross-hatching are combined with gestural lines to achieve movement and excitement in this pet portrait.

RUTH L. ERLICH

Attila

9" × 6" (23 cm × 15 cm)

Pencil on watercolor paper

This drawing is part of a series of studies for sculptures.

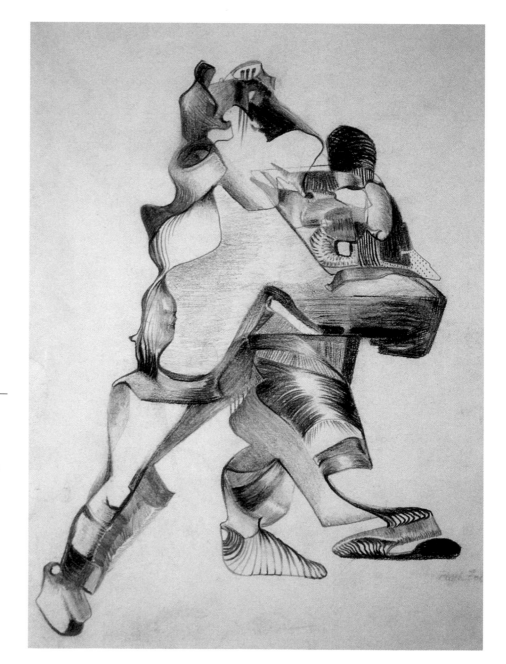

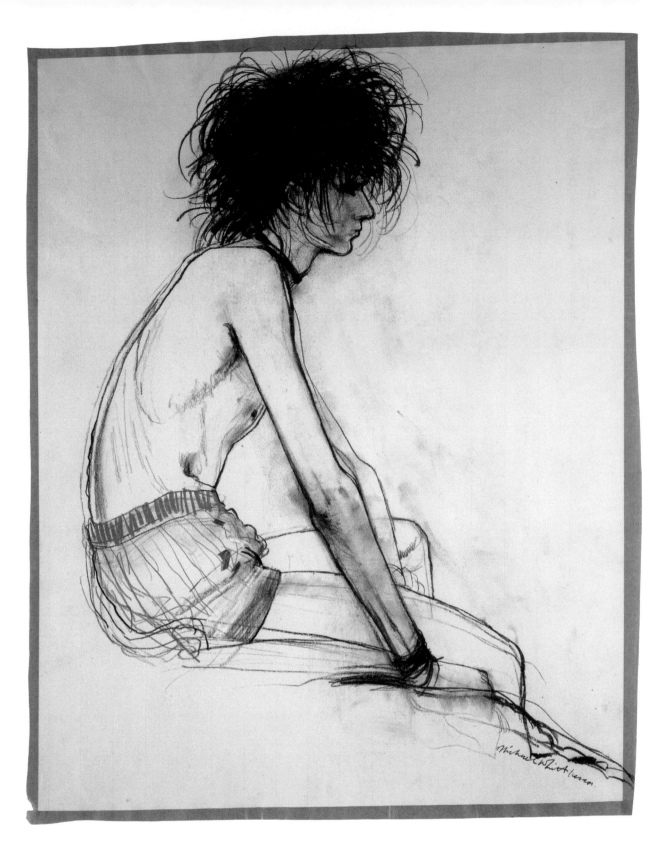

MICHAEL WHITTLESEA

Punk

24" × 19" (61cm × 48 cm)

Conté and chalk on Fabriano Ingres
paper

There is a wonderful tension between
the carefully controlled contour lines
(especially in the handling of the figure's
profile) and the exuberant, uncontrollable
energy in the rendering of the hair.

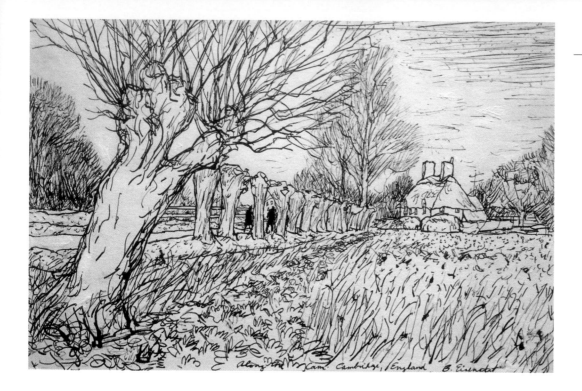

Along the Cam

13" × 19" (33 cm × 48 cm)

Pen and ink on cold pressed watercolor paper

This sketch was done en plein air, which means that an artwork was created outdoors and on site. The energy and attention that went into the making of this sketch recalls the plein-air drawings of Van Gogh.

Timothy Stotz

Veronica's Opposition

18" × 13" (46 cm × 33 cm)

Pencil on Arches text laid paper

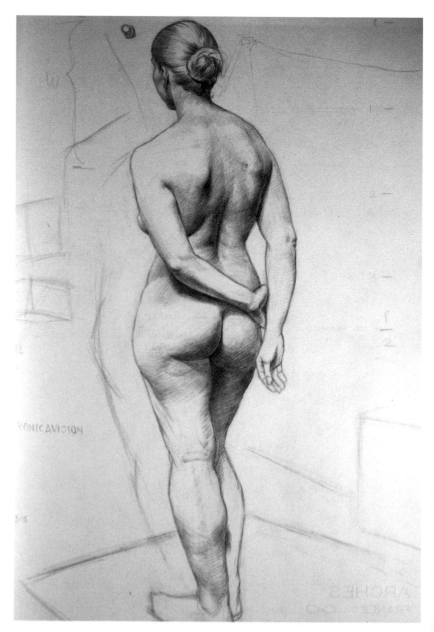

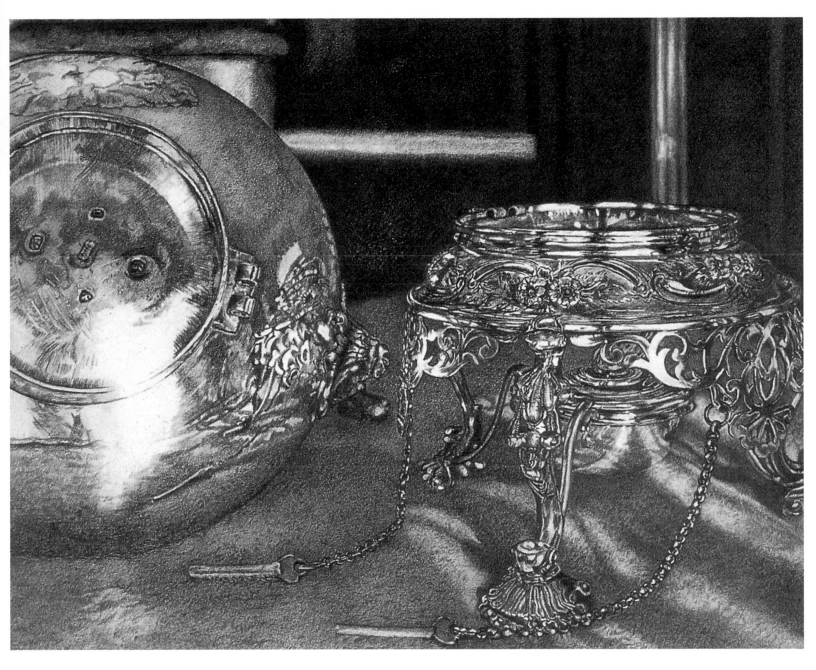

NEDRA TORNAY

Silver

10½" × 12" (27 cm × 30 cm)

Pencil on bristol board

Using parallel hatch marks, the artist
created a variety of values and texture.
For Tornay, pencil on paper is ideal for
portraying silver objects.

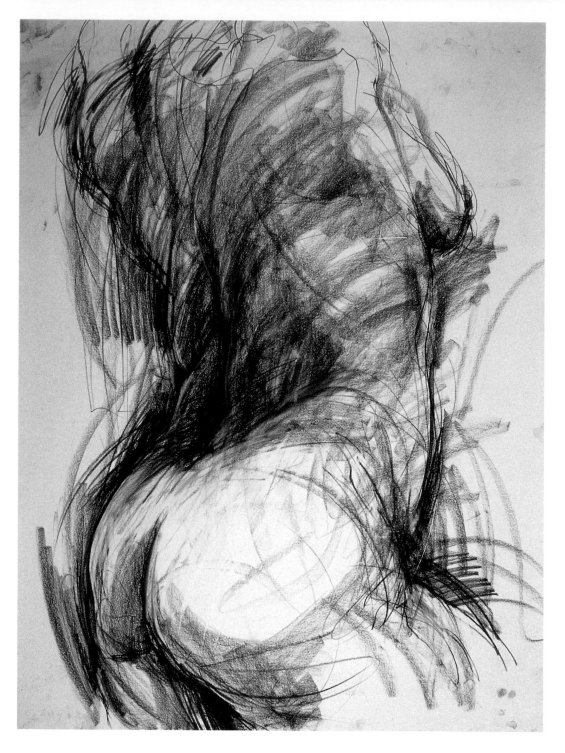

BARBARA FUGATE

Lucia, Back View

50" × 38" (127 cm × 97 cm)

Red chalk on paper

The artist has used line-gesture and mass-gesture—which are both different types of gesture drawings—to locate and build up the form of the figure on the paper.

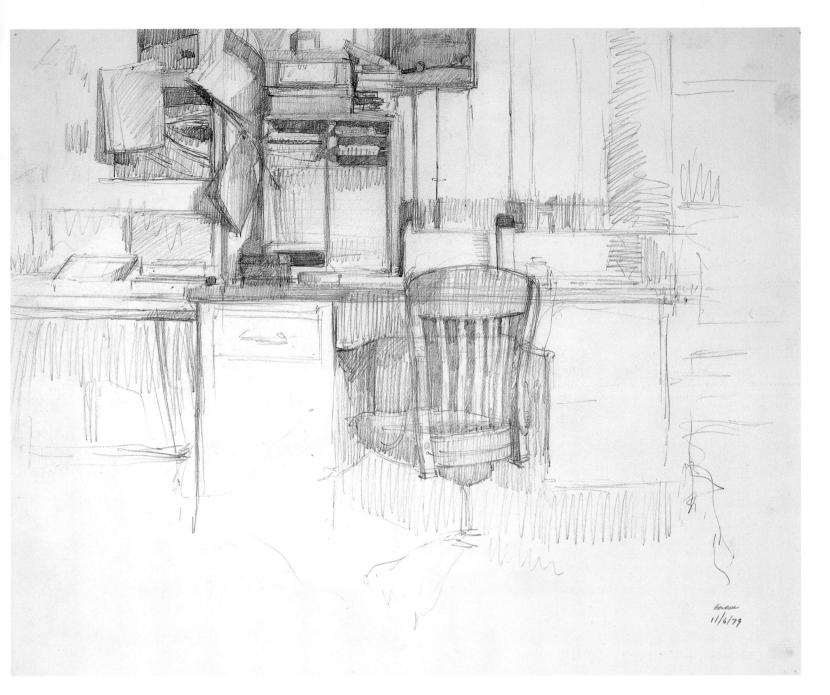

ALBERT HANDELL

Corner of My Studio

14" × 17" (36 cm × 43 cm)

Electronic Berol pencil on plate-finish
bristol board

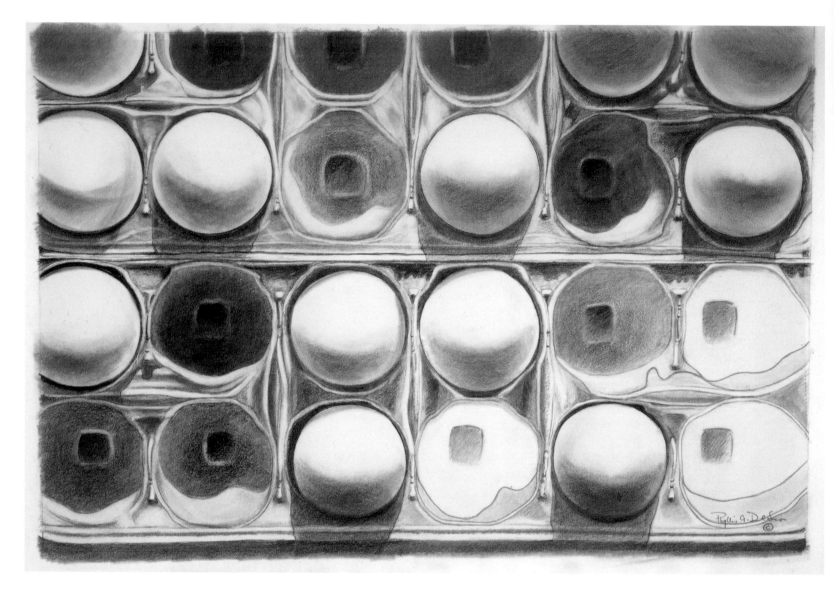

PHILLIS A. DE SIO

Eggs 'n' Crates
12" × 17" (30 cm × 43 cm)
Pencil on Rising bristol vellum

ANNE BAGBY

Black-and-White Still Life

29" × 29" (74 cm × 74 cm)

India ink, crowquill pen, black colored
pencil on paper

In this work, the artist has decorated the
mat with a paisley pattern, making it an
integral part of the composition.

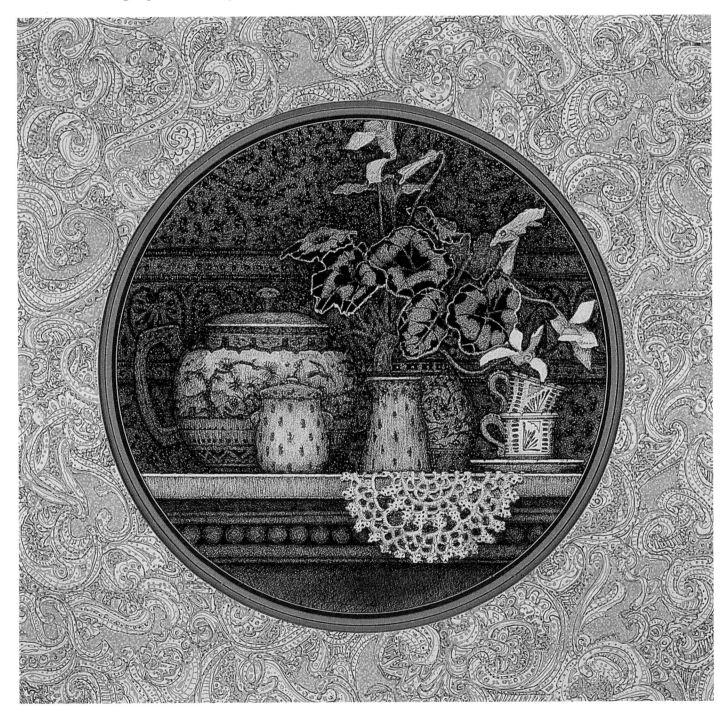

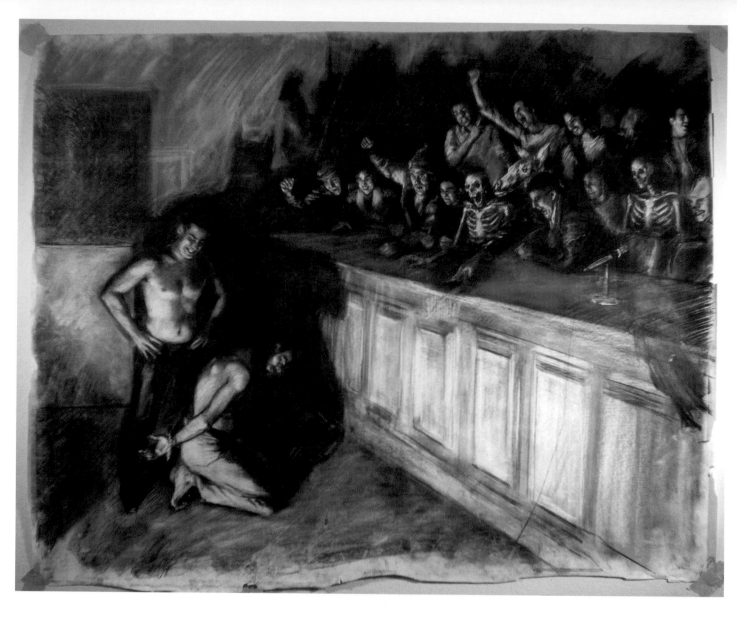

DAVE LEBOW

The Accusation

48" × 60" (122 cm × 152 cm)

Charcoal and white chalk on paper

In the dark tonality of the composition and the satirical way Lebow uses the courtroom, Lebow's preliminary drawing is reminiscent of the work of the great nineteenth-century French artist Honoré Daumier.

VIOLET BAXTER

16th-Floor View

22" × 30" (56 cm × 76 cm)

Charcoal on paper

Using two-point perspective, Baxter is able to calmly map out the hectic order of Manhattan.

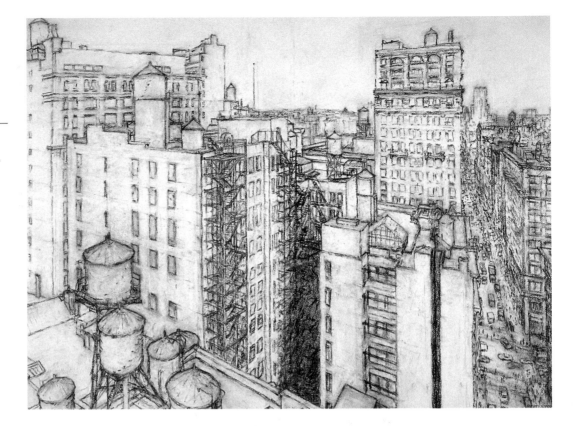

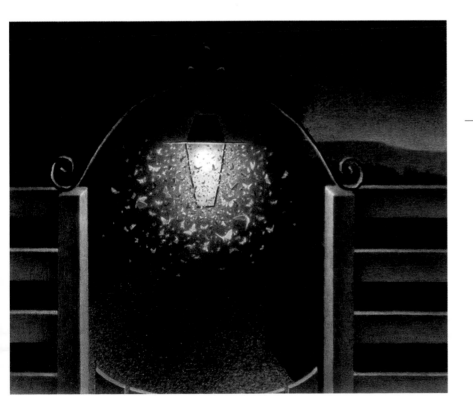

ROB EVANS

The Lure

14½" × 17½" (37 cm × 44 cm)

Pencil and powdered graphite on paper

The mysterious and unsettling quality of this image is achieved by contrasting the chaotic rhythm of the moths with the calm appearance of the lamp, the fence, and the landscape.

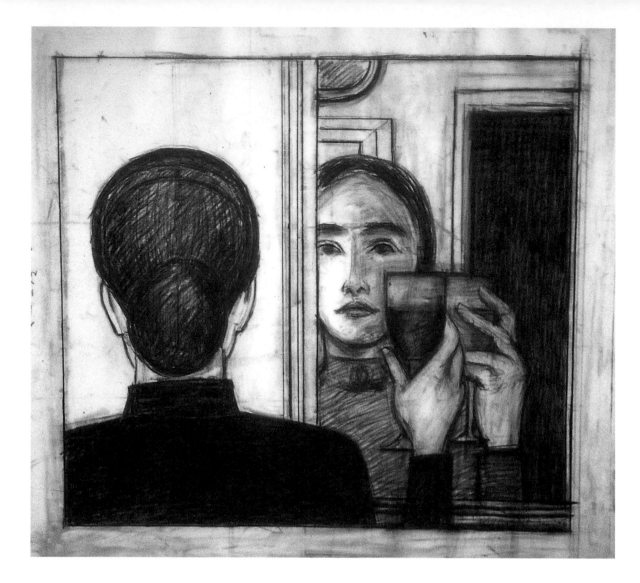

WILL BARNET

The Glass

Charcoal on vellum

23$\frac{1}{2}$" × 21$\frac{1}{2}$" (60 cm × 55 cm)

The title of this drawing refers to both the glass of wine the woman holds in her hand as well as the mirror in which the woman's face is reflected. What is also interesting about this work is that, realistically, we should not be able to see the woman's face in the mirror because of the angle in which she faces the mirror. However, this is a painting and not a photograph, consequently, the artist rearranges the composition to suit his needs.

WOLF KAHN

Portrait of Fairfield Porter

18" × 14" (46 cm × 36 cm)

Pencil on paper

An interesting form of portraiture is when one artist decides to depict another. Here, the artist Wolf Kahn, who created this portrait of the artist Fairfield Porter in 1953, makes wonderful use of gesture drawing—an element that appears in the paintings of both artists.

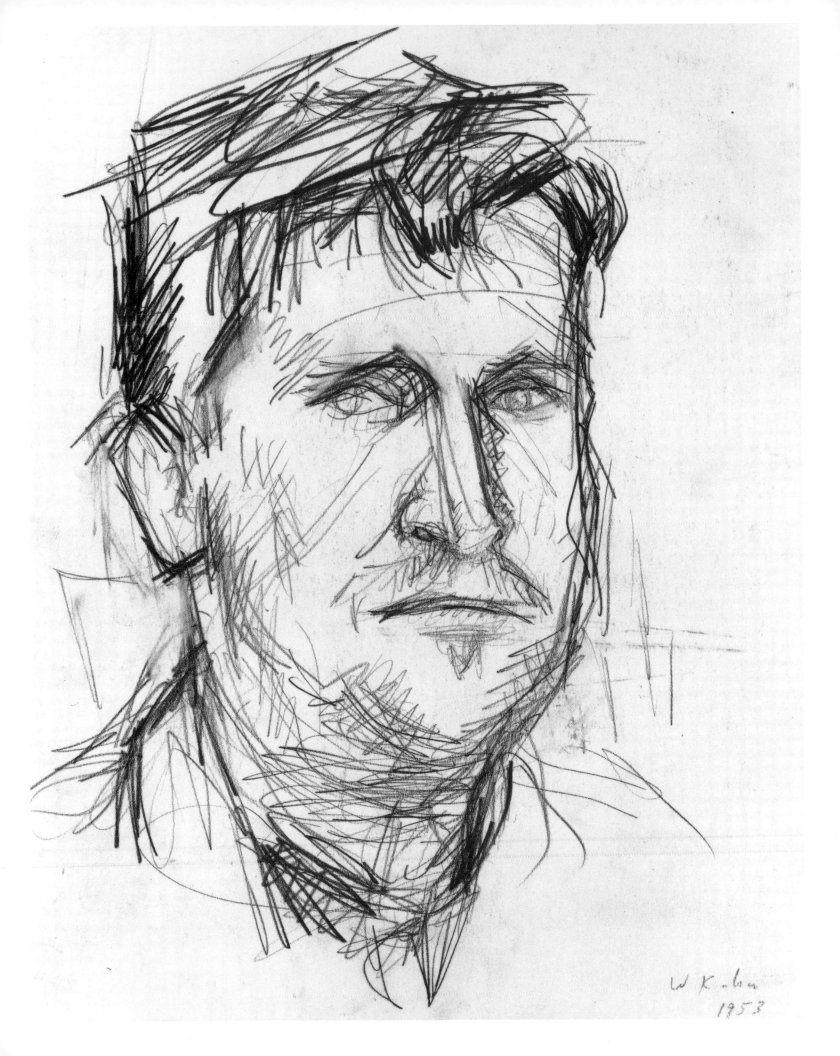

RITA BARAGONA

Ebb and Flow—Oceanscape

$5^{1}/_{2}$" × 16" (14 cm × 41 cm)

Sumi brush and ink on paper

Baragona says she enjoys working in line to activate the white space on the paper. She is interested in capturing the energy, movement, and mass of a landscape.

MATTHEW BUCKNER

Self-portrait

11" × 14" (28 cm × 36 cm)

Pencil on paper

Self-portraiture is attractive to artists because it is a private activity, one in which the artist doesn't have to worry about pleasing anyone else. There is a unique sense of dialogue between the artist as observer and the artist as creator. Because the artist here has chosen to hide the pupils in shadow, one almost gets the sense that the figure depicted is blind. For an artist, it is a haunting image!

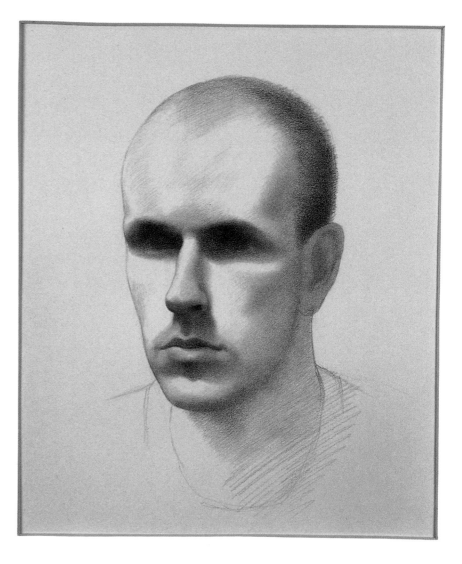

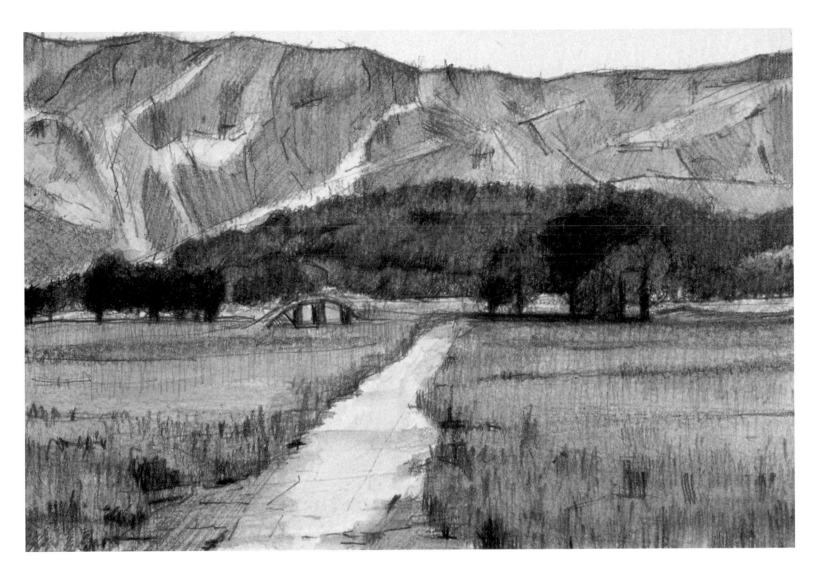

DIANE ELIZABETH JONES

Derwent

4" × 6" (10 cm × 15 cm)

Wash pencils and graphite pencils on watercolor paper

In landscapes that incorporate perspective, artists have often included pathways as directional forces to pull viewers into the scene. Other types of similar devices include railroad tracks and a line of telephone polls.

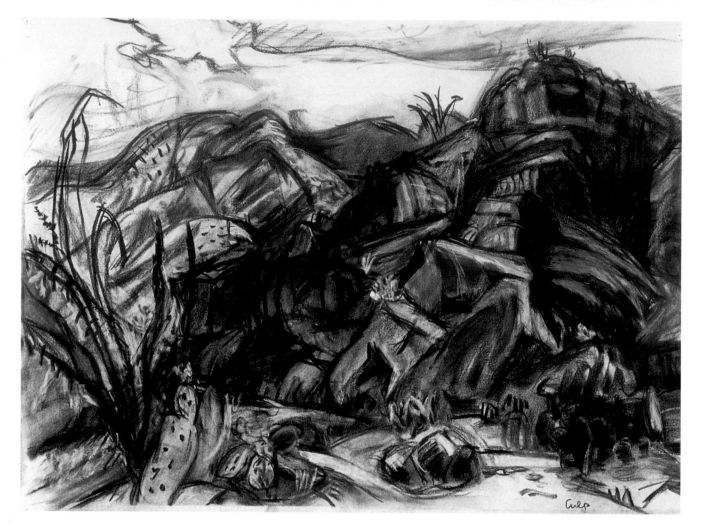

Jane Culp

Narrows Earth Trail—Anza Barrego Desert

22" × 30" (56 cm × 76 cm)

Charcoal and chalk on Rives BFK paper

Culp's landscape drawings rely more on her emotional response to the land than on a photographic record-keeping of the scene. Instead of depicting each and every tree on the mountainside, she uses a type of shorthand to generalize and condense the panorama.

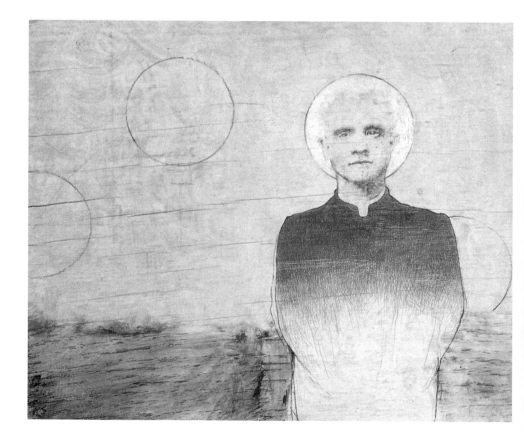

JEFFREY HAYMAN

The Priest Crowned by the Moon

8" × 10" (20 cm × 25 cm)

Silverpoint and oil paint on panel

Hayman employs a centuries-old drawing technique by using silverpoint, a method of drawing using a small rod of silver on a specially prepared ground. The silver oxidizes over time to a brownish color. One of the trickiest aspects of this technique is that the artist cannot correct the lines. In this work, Hayman demonstrates exceptional control over the medium and the composition.

DALE JARRETT

Approach

10" × 20" (25 cm × 51 cm)

Pencil and carbon on hot-pressed watercolor paper

Jarrett's approach to drawing is one that emphasizes the tonal more than the linear, and places more importance on the overall composition rather than on the details. It's a technique that calls to mind the drawings of Seurat.

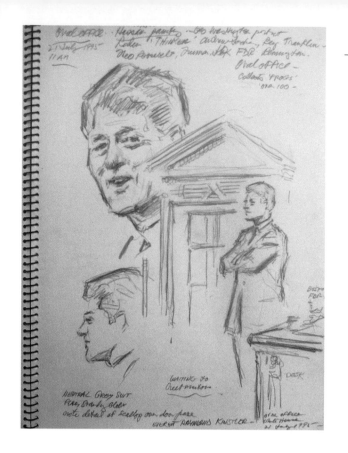

EVERETT RAYMOND KINSTLER

Life Sketches of President Bill Clinton

13" × 9½" (33 cm × 24 cm)

Pencil on paper

Kinstler focuses in on a number of elements in preparing for this portrait of President Clinton. In this sketch, he not only captures three views of the president in the Oval Office, but also depicts part of the desk and a window or doorway. In his drawing, he also notes that the president has a bust of another president, Franklin Delano Roosevelt, on his desk.

LOUIS FINKELSTEIN

Oak Grove—Dorland

11" × 13¾" (28 cm × 35 cm)

Pencil on paper

The artist seems to move through this landscape by picking only selected details—a leaf here, a branch there. In doing so, his landscape has an emotional immediacy, one that borders on the edge of abstraction.

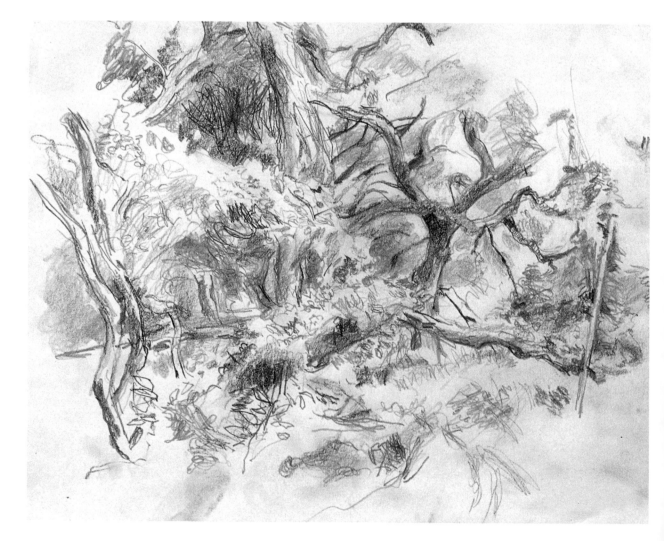

Ilona Malka

Show Faith

13½" × 10" (34 cm × 25 cm)

Graphite and ink on paper

Malka combines a variety of images—a
Cézanne self-portrait, cartoons, carica-
tures, and doodles—to make a humorous
commentary on the concept of faith.

SERGE HOLLERBACH

Man Reading

5" × 3¾" (13 cm × 10 cm)

Pen and ink on paper

This intimate sketch was made on-site at an airport. What is moving about this sketch is that the reading figure seems to reflect the same concentration that the artist who made this sketch reveals in his attention to detail.

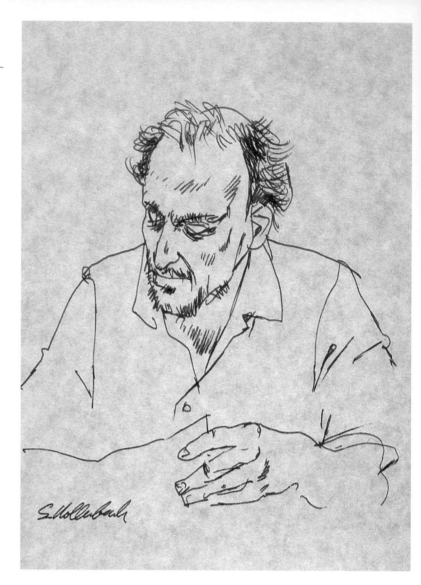

DENNIS REVITZKY

Paper Series: Torn Fragments

21" × 27" (53 cm × 69 cm)

Carbon pencil on paper

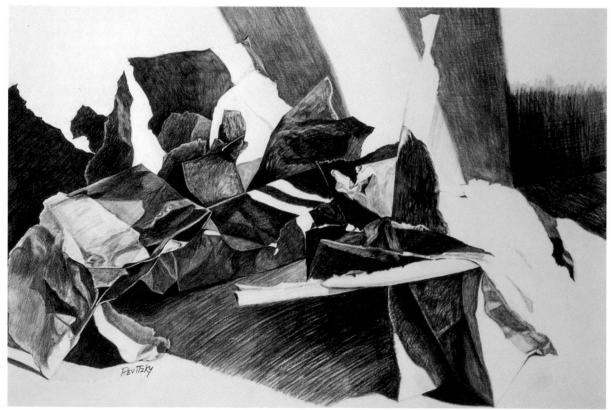

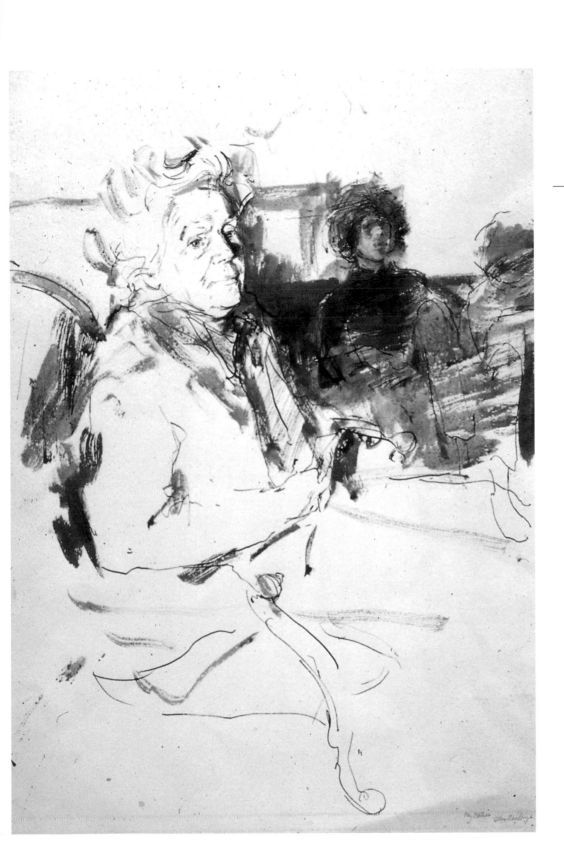

JOHN EVELEIGH

*My Mother Josephine and Her Eldest
Son Aldous*

20½" × 14⁷/₁₆" (52 cm × 37 cm)

Pen and ink on paper

The artist used the feathers of a turkey quill to apply the ink in this double portrait. The artist also creates a sense of space by casting one figure in shadow and one figure in light.

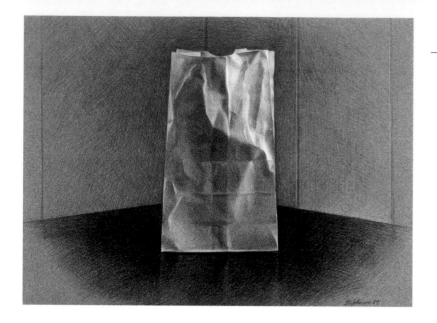

BARBARA JOHNSON

White Bag

19" × 25" (48 cm × 64 cm)

Black and white charcoal pencil on gray paper

The artist says she enjoys classically composing simple objects in transitory settings.

KAREN FREY

Jane

22" × 15" (56 cm × 38 cm)

Pencil on rag drawing paper

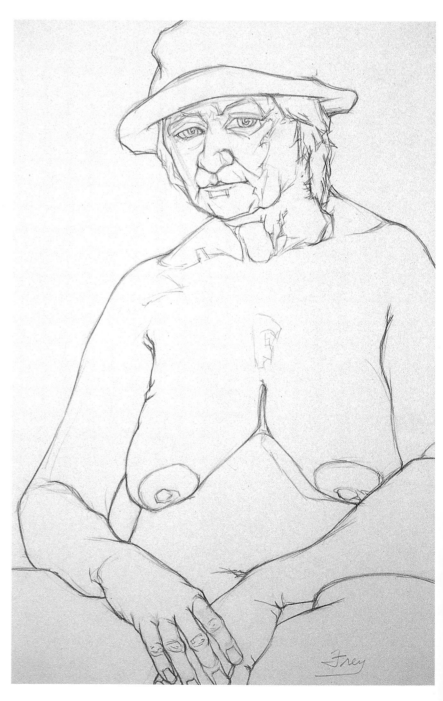

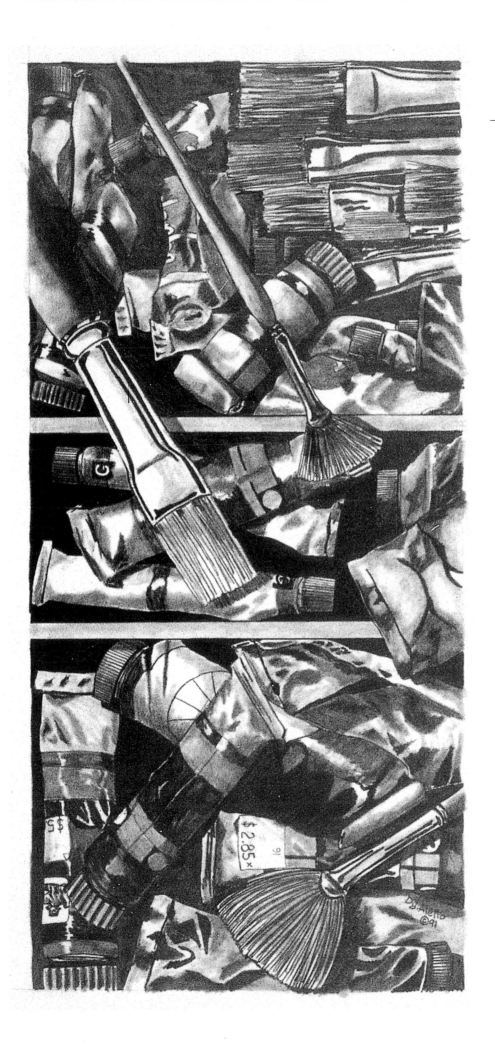

DARRYL D. ALELLO

In My Paint Box
11" × 5" (28 cm × 13 cm)
Pencil on vellum

63

MICHAEL A. GRIMALDI

Drapery Study A

16" × 14" (41 cm × 36 cm)

Pencil on paper

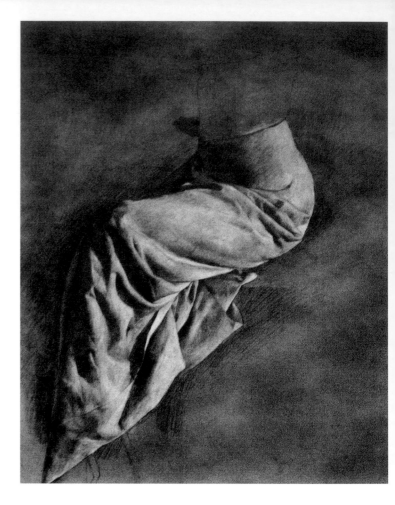

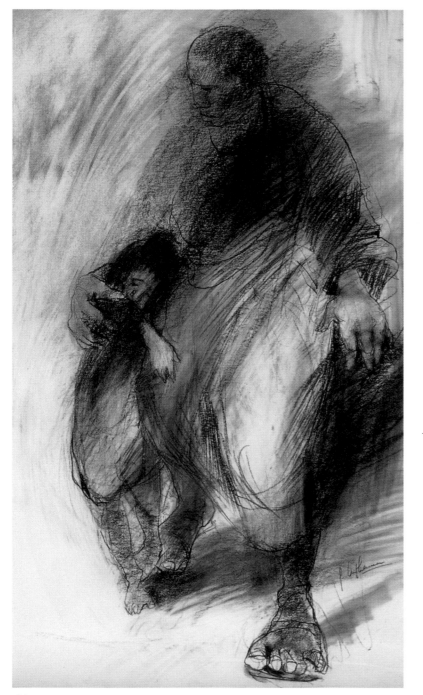

GRETA AUFHAUSER

Flight from the Riots

37" × 22" (94 cm × 56 cm)

Conté on board

The artist uses exaggerated proportion to emphasize the feelings of fear and security. Compositionally, Aufhauser contrasts expressive lines, which are used for tone, with delicate contour lines to delineate the figures.

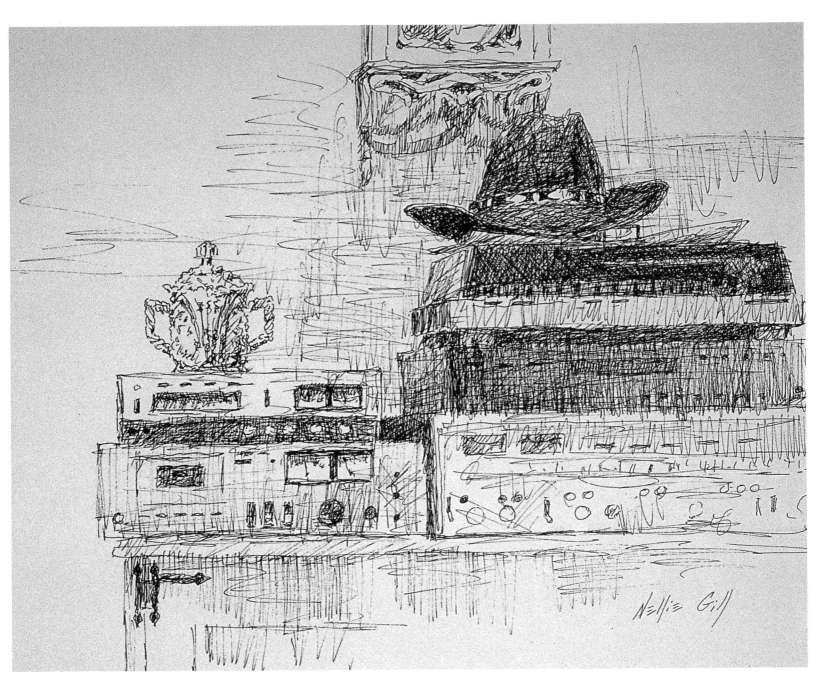

NELLIE GILL

Hat, Audio System, and Crystal

11" × 13" (28 cm × 33 cm)

Pen and ink on bristol board

The irregular shapes of the cowboy hat and sugar bowl contrast with the stereo system, which is mostly made up of rectangles.

TED VAUGHT

Bug Crusher

$21^{1}/_{2}"\times29^{1}/_{2}"$ (55 cm × 75 cm)

Pen and ink on paper

Vaught captures energy, speed, spontaneity, and immediacy in the forms he creates.

JERRY WEISS

Dan

24" × 18" (61 cm × 46 cm)

Charcoal pencil and white conté on brown paper

By drawing on a middle-toned ground, the artist is able to utilize both lighter and darker values to create a broader value scale.

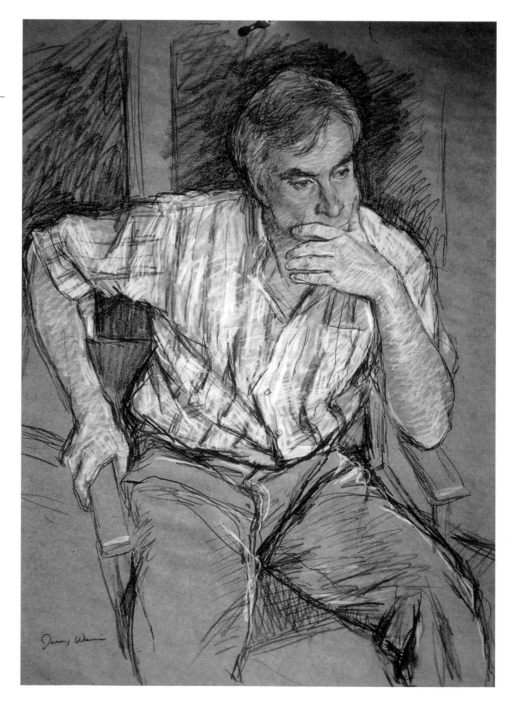

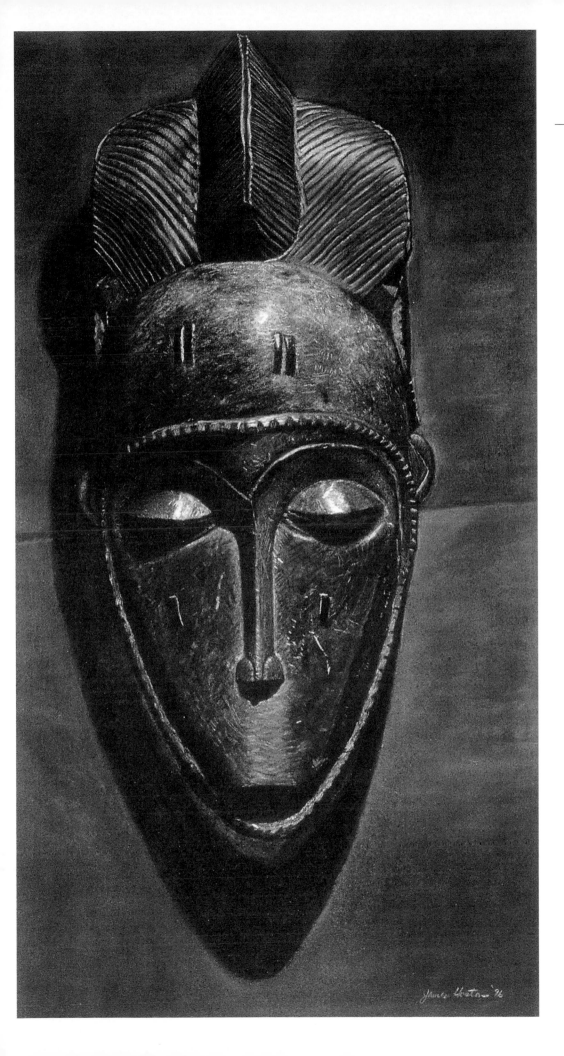

JAMES HOSTON

Mask II (Drawing)
$21^{1}/_{2}$" × $11^{1}/_{2}$" (55 cm × 29 cm)
Charcoal and conté on paper

ANITA LOUISE WEST

Grant

7" × 12" (18 cm × 30 cm)

Pencil on paper

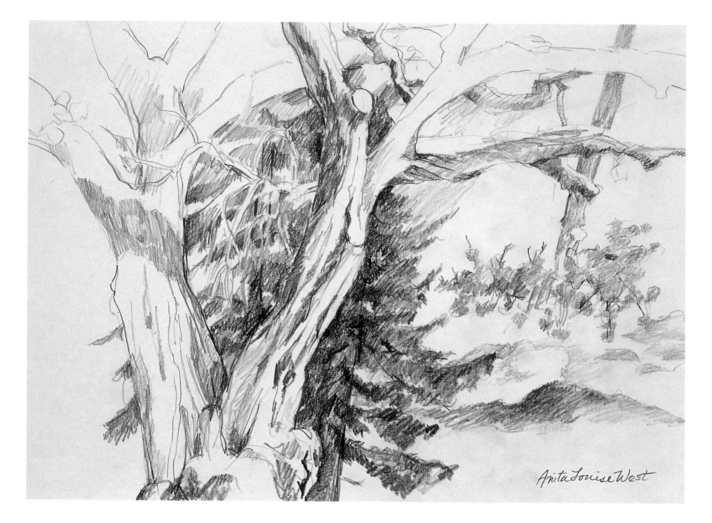

SUSAN WEBB TREGAY

Come Over to My House

22" × 30" (56 cm × 76 cm)

Pen and ink on hot-pressed paper

Inspired by the doodles of Arshile Gorky and Charles Burchfield, Tregay created this nervous-looking house out of a doodle of her own.

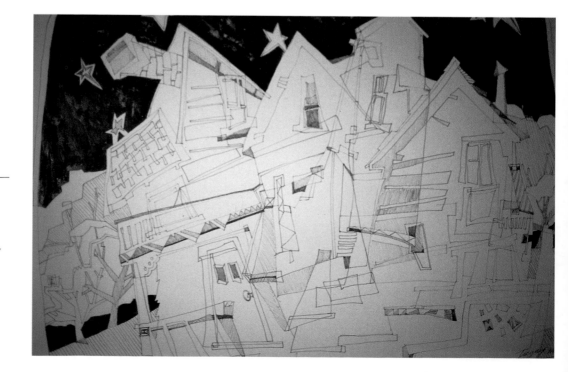

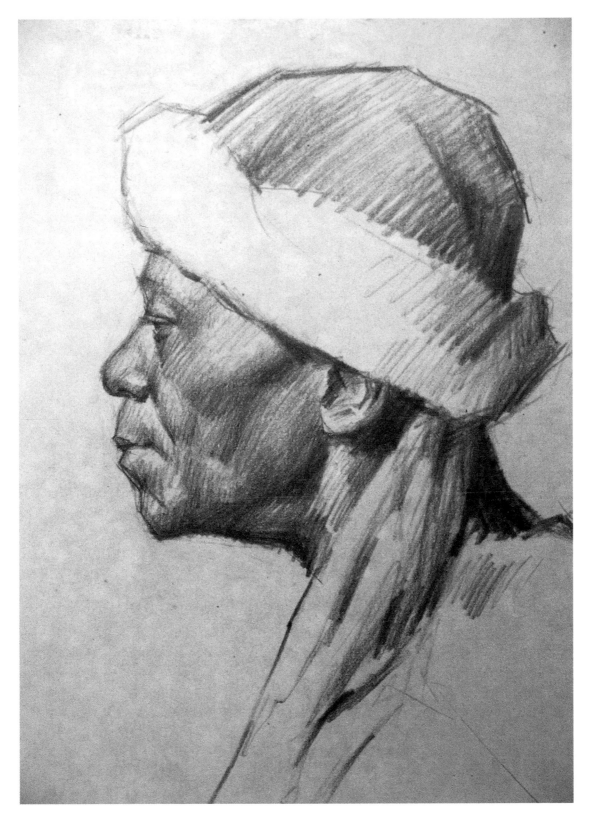

JOE HING LOWE

Profile of a Man

20" × 16" (51 cm × 41 cm)

Pencil on paper

For this artist, the correct tonal values
are accomplished by using the right
amount of pressure on the pencil.

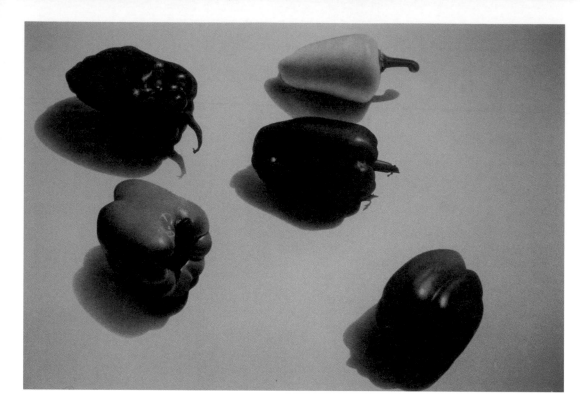

DONNA BASILE

Five Peppers
18½" × 20½" (47 cm × 52 cm)
Charcoal on mat board

SUSAN COTTLE

Untitled
15" × 8½" (38 cm × 22 cm)
Ink on blue vellum

The artist distorts the second toe in this
drawing to achieve a disturbing, yet
riveting effect.

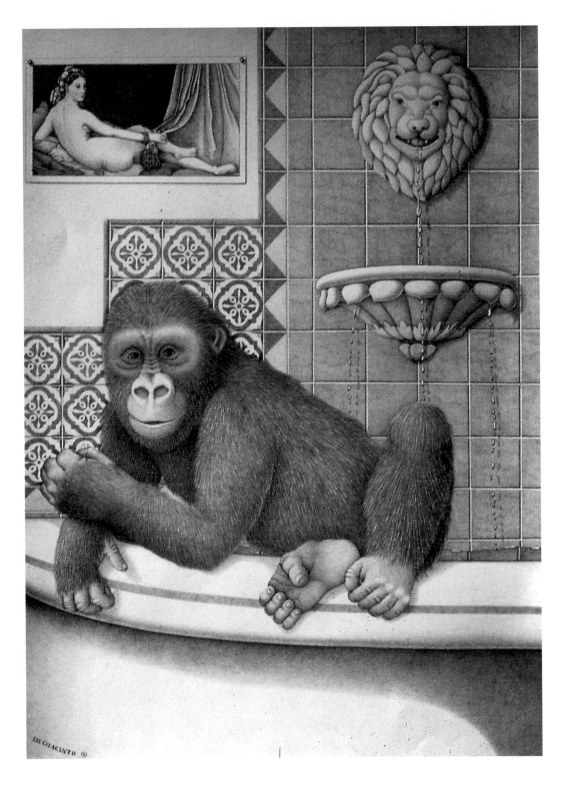

SHARON DiGiacinto

Odalisque

29" × 21" (74 cm × 53 cm)

Pencil on watercolor paper

The nude picture included in this drawing refers to one of the most famous paintings of the 19th century, *Odalisque* by Jean-Auguste-Dominique Ingres (1780–1867). DiGiacinto seeks to evoke a humorous response as well as question the concept of beauty by juxtaposing this masterpiece with a depiction of a monkey.

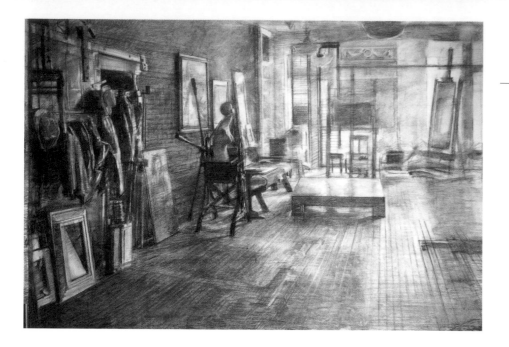

THOMAS R. LOEPP

Studio

27" × 39" (69 cm × 99 cm)

Charcoal on rag paper

PATRICIA BROWN

Sense-Ability

22" × 30" (56 cm × 76 cm)

Ink and watercolor wash on watercolor paper

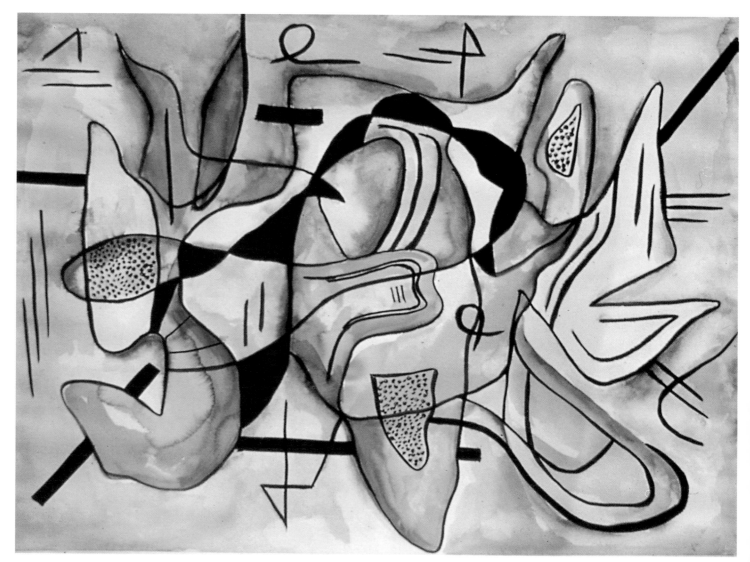

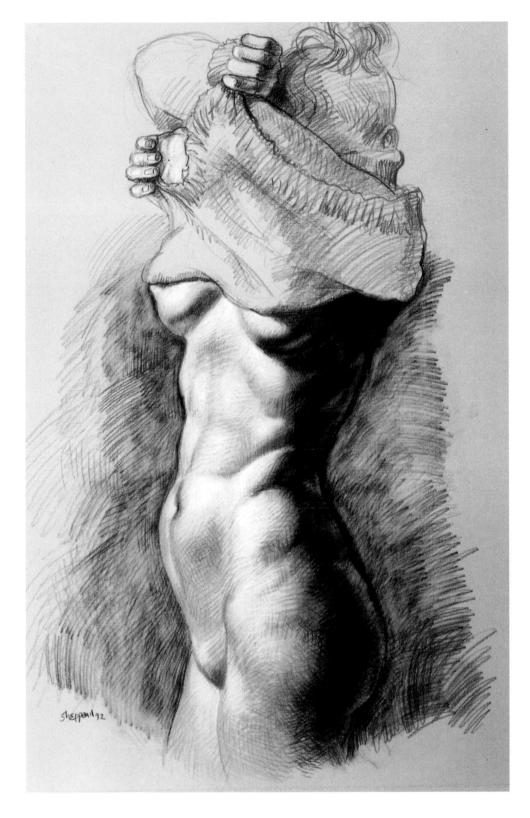

JOSEPH SHEPPARD

Girl Taking off Her Sweater

36" × 30" (91 cm × 76 cm)

Charcoal, red and white conté on beige
paper

BETTY LYNCH

School's Out

9" × 12" (23 cm × 30 cm)

Pen and ink on paper

By concentrating on the negative shapes—the shadow areas, Lynch creates an intriguing composition.

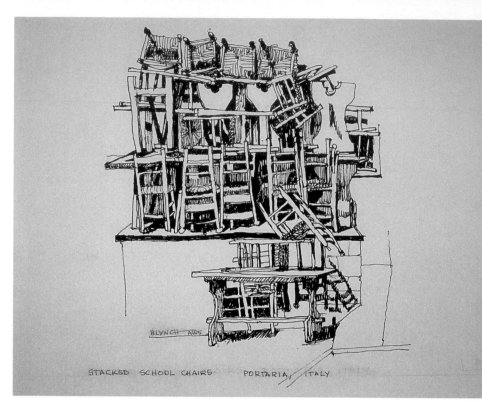

JUDY CASSAB

Transparent Landscape—Rainbow Valley

30" × 40" (76 cm × 102 cm)

Charcoal on paper

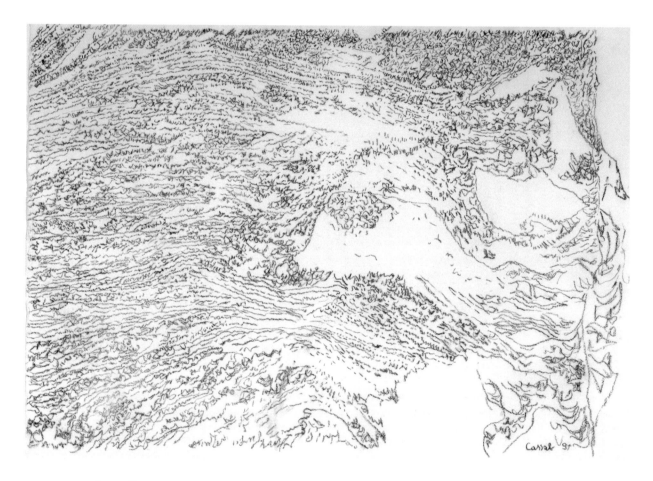

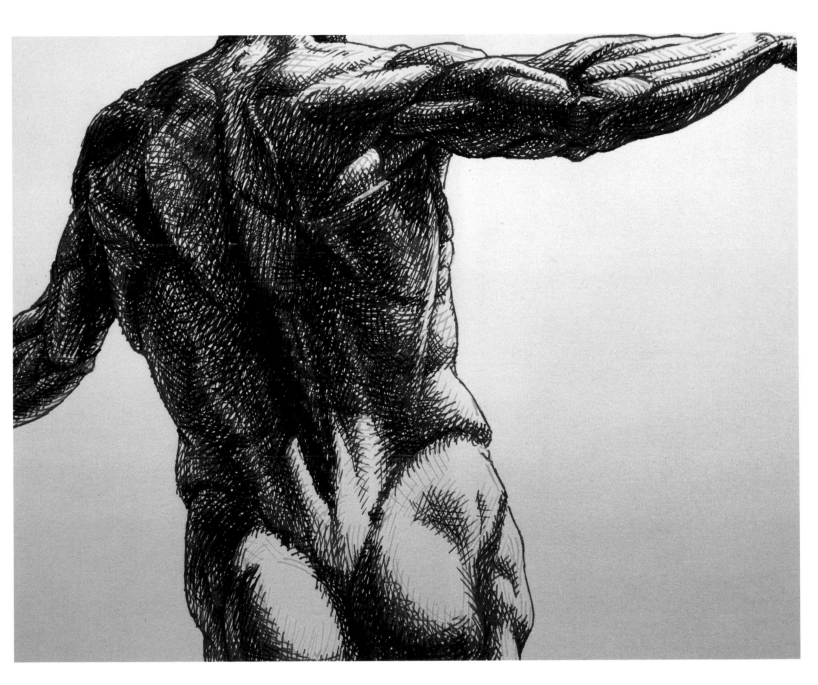

ANDY SYRBICK

Body Parts: Torso, Back
8" × 10" (20 cm × 25 cm)
Pen and ink on paper

MARY ALICE BRAUKMAN

Layers

4" × 5" (10 cm × 13 cm)

Pen and ink on watercolor paper

Braukman uses sketches for developing ideas to her paintings. One of her favorite sources for generating ideas is working from newspaper photographs, especially sports-action shots.

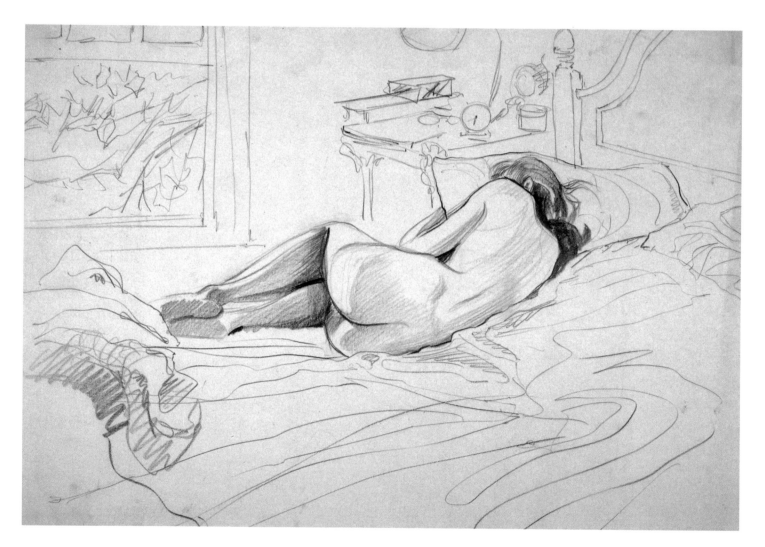

JOHN T. ELLIOT

Morning Chill

19" × 24" (48 cm × 61 cm)

Pencil on paper

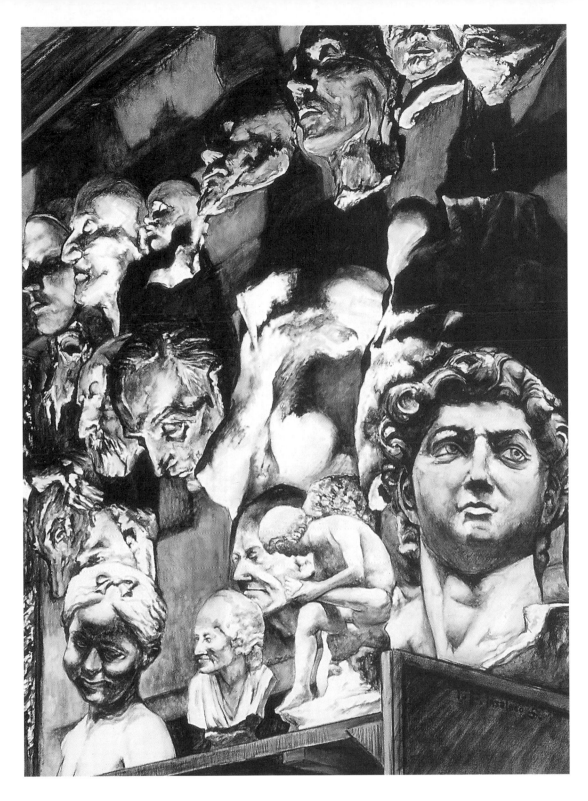

T. F. Insalaco

Study for Homage: Double Self-portrait at 50

40" × 30" (102 cm × 76 cm)

Charcoal with turpentine washes on stretched canvas

The artist used turpentine to dissolve the charcoal and create subtle washes. In this work, he pays homage to many of the great artists of the past.

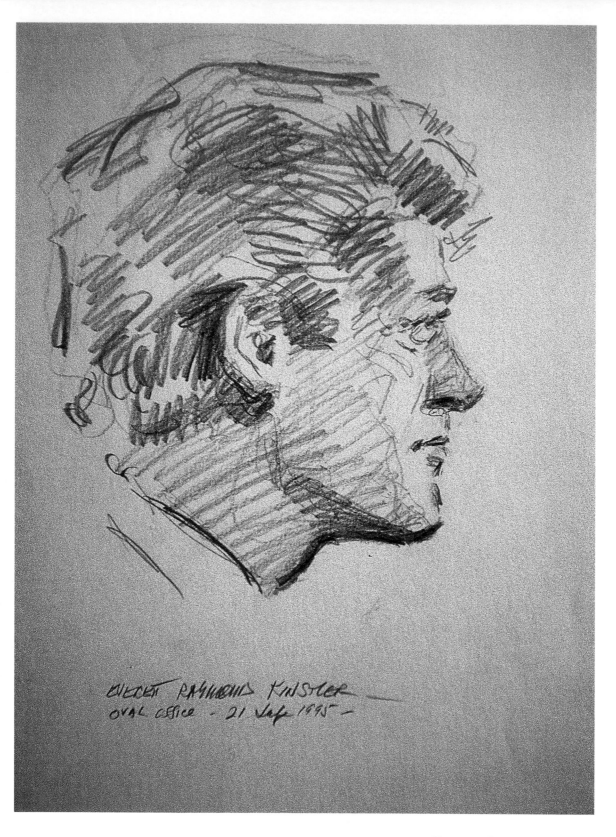

EVERETT RAYMOND KINSTLER

Life Sketches of President Bill Clinton

13" × 9¹/₂" (33 cm × 24 cm)

Pencil on paper

FLEUR BYERS

Windows and Shadows

17$\frac{1}{2}$" × 23" (44 cm × 58 cm)

Charcoal on paper

There are no right angles—and thus
no true squares or rectangles—in the
whole drawing. This work relies on
the dominance of diagonals.

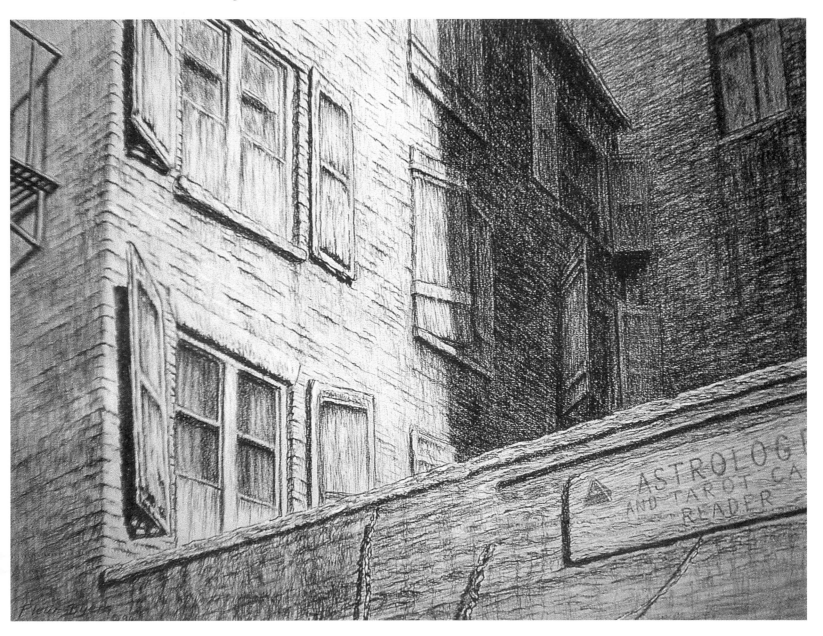

DALE JARRETT

The Path

8" × 17" (20 cm × 43 cm)

Carbon pencil and pencil on hot-pressed watercolor paper

The pathway in this composition breaks the rhythm set up by the vertical and horizontal elements.

BONESE COLLINS TURNER

Midwest Soliloquy

11¼" × 12" (28.5 cm × 30.5 cm)

Pencil and powered graphite on paper

WILL BARNET

Return from Paris

36½" × 37½" (93 cm × 95 cm)

Carbon pencil on vellum

Line has always been extremely important to Barnet, who has been influenced not only by the master draftsmen of Western art such as Rembrandt and Daumier, but by the art of Central America, China, Japan, Egypt, and Mesopotamia. Of Assyrian art, he says, "Their drawing is so powerful, full of energy and physical play without being realistic. It's just the line itself, which is like magic!"

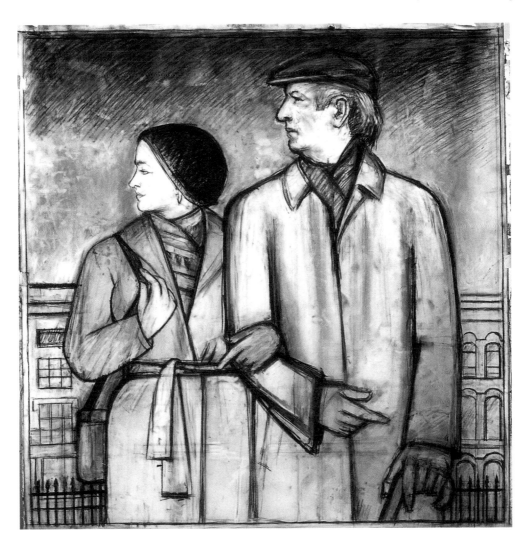

Morris Shubin

Waiting Patterns

12" × 15" (30 cm × 38 cm)

India-ink sketch

The artist has reduced the tonal value of these three seated figures down to one tone—the shadows.

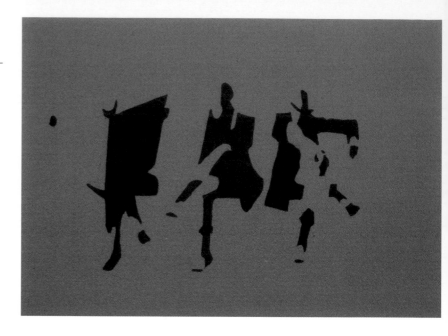

Edwin Douglas

Self-portrait V

11" × 15" (28 cm × 38 cm)

Charcoal, wash, and gouache on rag paper

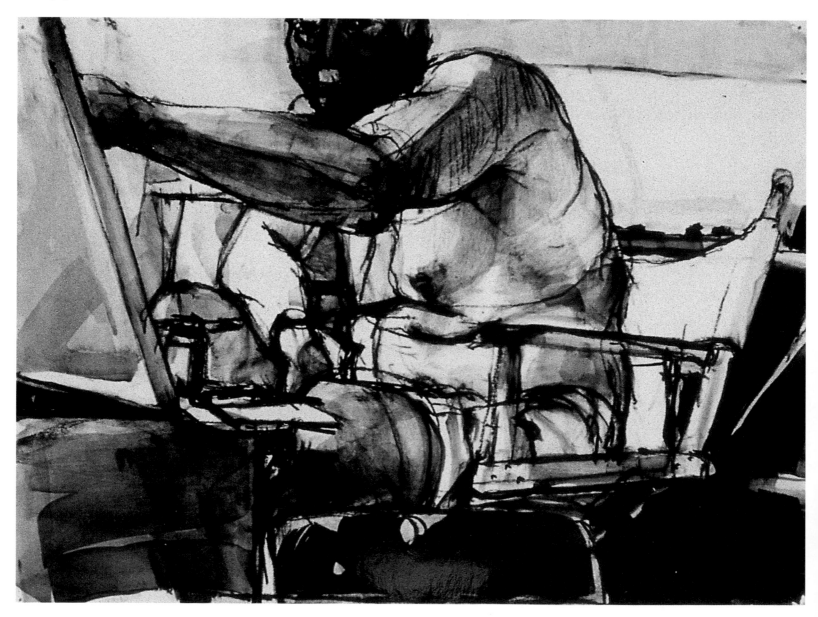

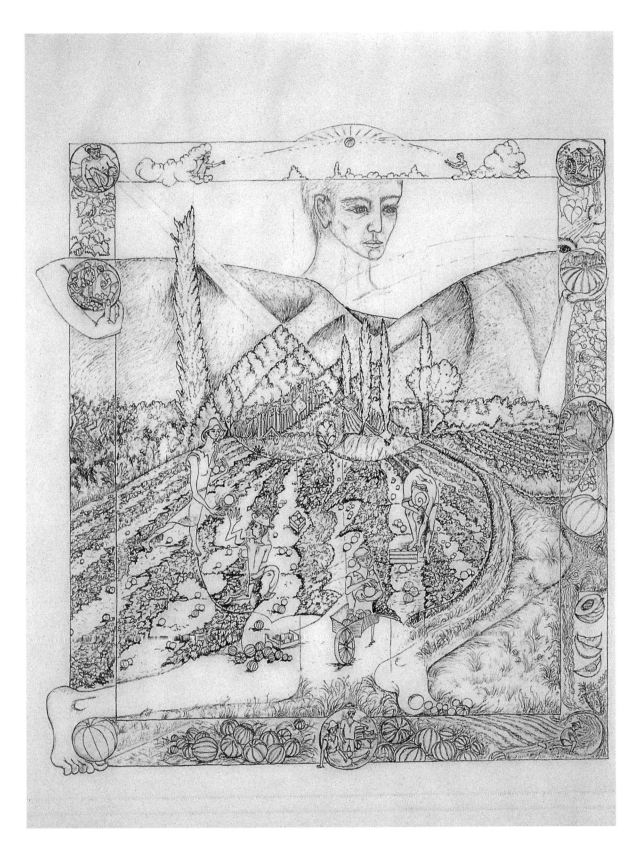

CRYSTAL WOODWARD

In the Melons

12" × 10¹/₂" (30 cm × 27 cm)

Black, sepia, and yellow ink on paper

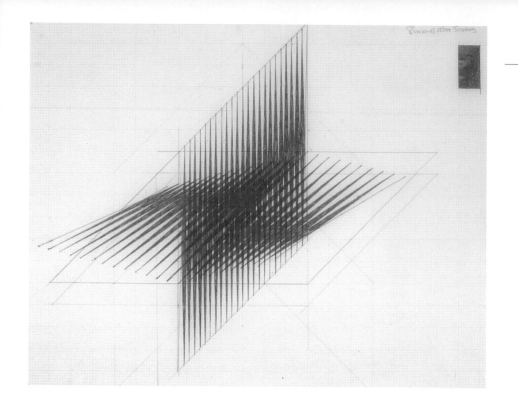

CHRISTOPHER WILLARD

Gale: Oarashi

17" × 22" (43 cm × 56 cm)

Pen and ink on grid paper

What's intriguing about this drawing is that although it is entirely abstract, the form suggests depth and movement without referring to anything representational or realistic.

ROB EVANS

Gravity Air

40" × 60" (102 cm × 152 cm)

Pencil and powdered graphite on museum board

Despite the factual, detailed realism depicted in this interior, there is a macabre quality to this diptych.

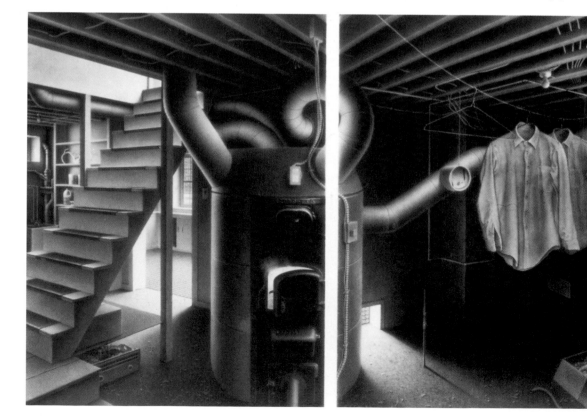

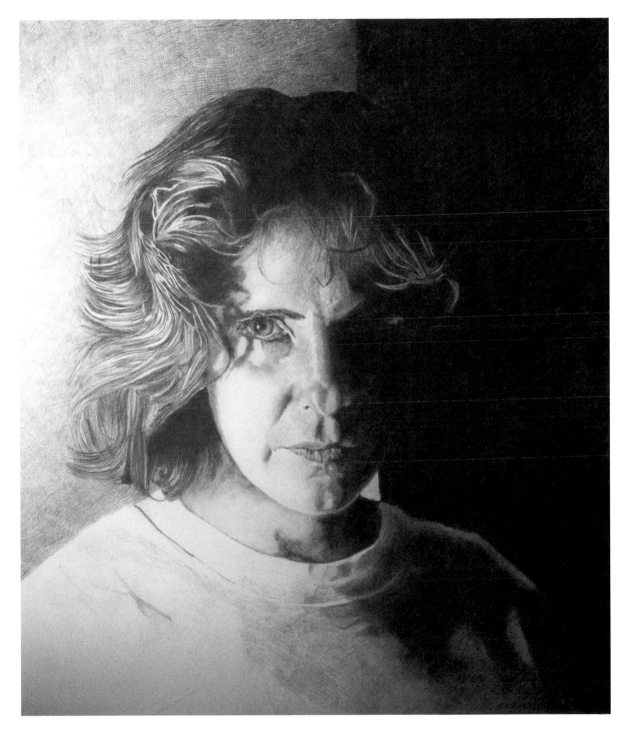

KATHRYN S. HEUZEY

Self-portrait—Looking at the Dark Side

26" × 24" (66 cm × 61 cm)

Pencil on paper

The strong contrast of light and dark conveys the emotional intensity in this work.

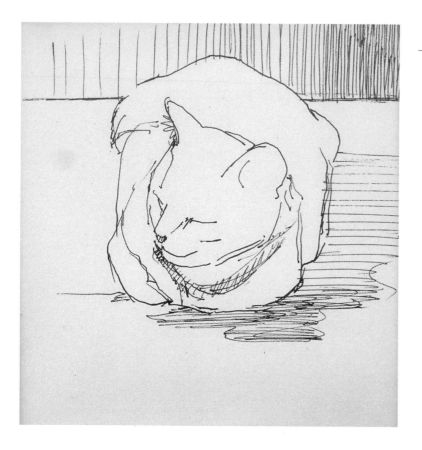

SUSAN OGILVIE

Cat Study

5¹/₂" × 5" (14 cm × 13 cm)

Pen and ink on paper

The series of horizontal lines, which form the cat's shadow, and the series of vertical lines, which define the edge of the table, help visually anchor the cat in the composition.

JUDITH KLAUSENSTOCK

Portrait of a Model—Adrian

13" × 16" (33 cm × 41 cm)

Charcoal on colored paper

The artist employed torn pieces of paper in this drawing to add another layer of texture.

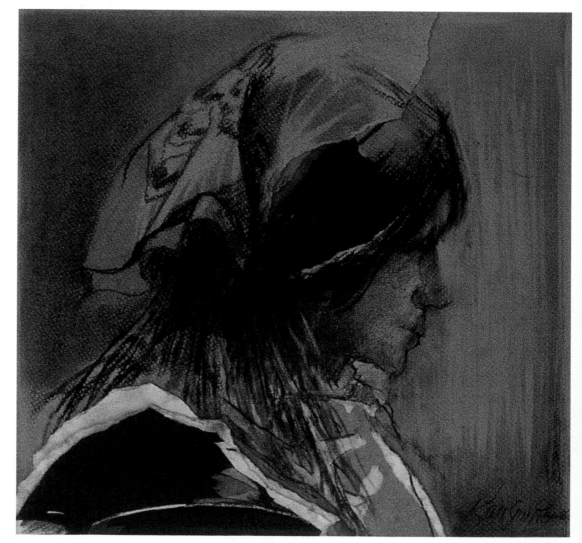

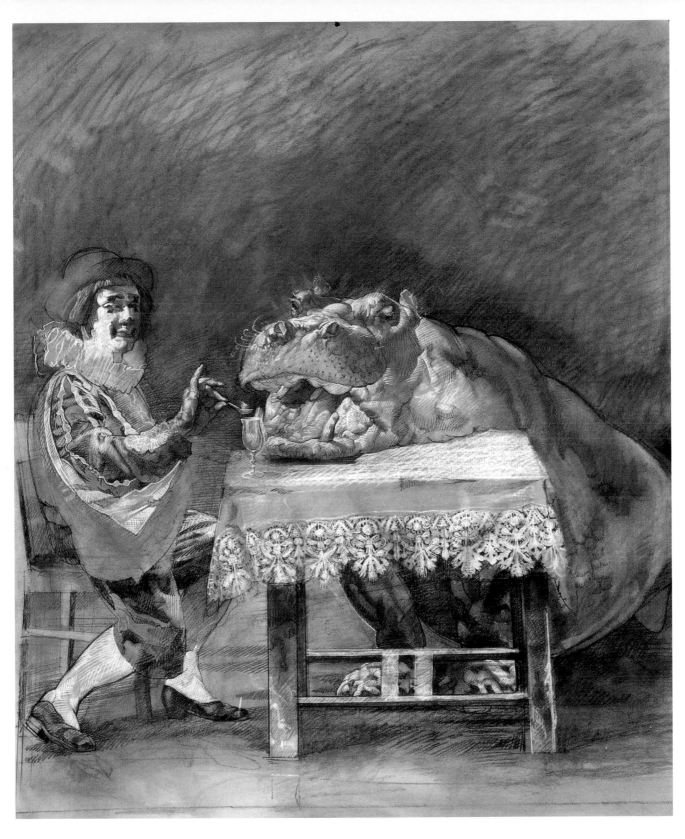

WILLIAM WOODWARD

Study for Gluttony

54" × 42" (137 cm × 107 cm)

Burnt sienna dry pigment and charcoal on toned paper with white charcoal

This humorous drawing is a study for a series of paintings based on the seven deadly sins. In terms of technique, the artist extended the value range of the composition by adding white. This technique is often called heightening.

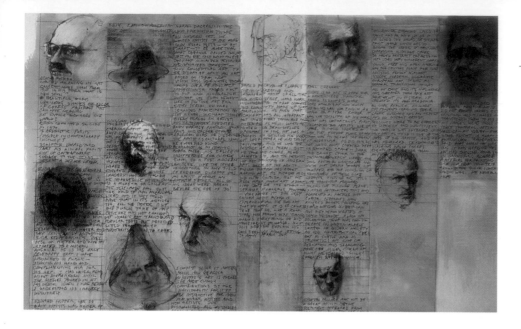

Artists

40" × 90" (102 cm × 229 cm)

Charcoal and opaque watercolor on Strathmore illustration board

In this work, Powers uses the images of famous twentieth-century artists to amplify the text. The fragmentary portraits have a mystical quality and appear like apparitions between written segments.

GREGORY KONDOS

Rosebud Farm, Sacramento River

11¼" × 12½" (28 cm × 32 cm)

Pencil on paper

Kondos's landscapes reflect his interest in the work of Cézanne. "What I admire about Cézanne," he says, "was how he was able to make an object's edge work in space. It's not a hard edge, but rather a broken one."

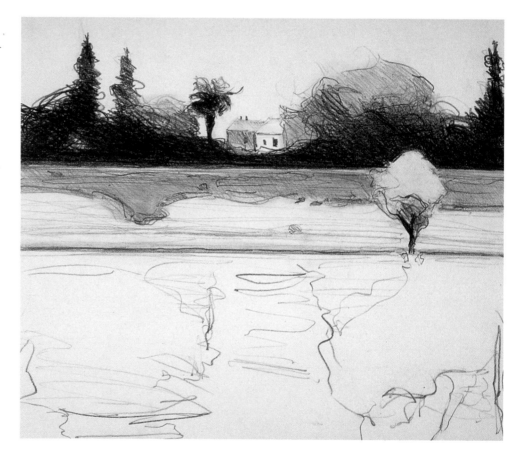

LAWRENCE WALLIN

Her

30" × 22¼" (76 cm × 56.5 cm)

Pencil on paper

This Picasso-esque drawing was used to accurately depict a wax sculpture before it was disassembled and turned into a bronze sculpture.

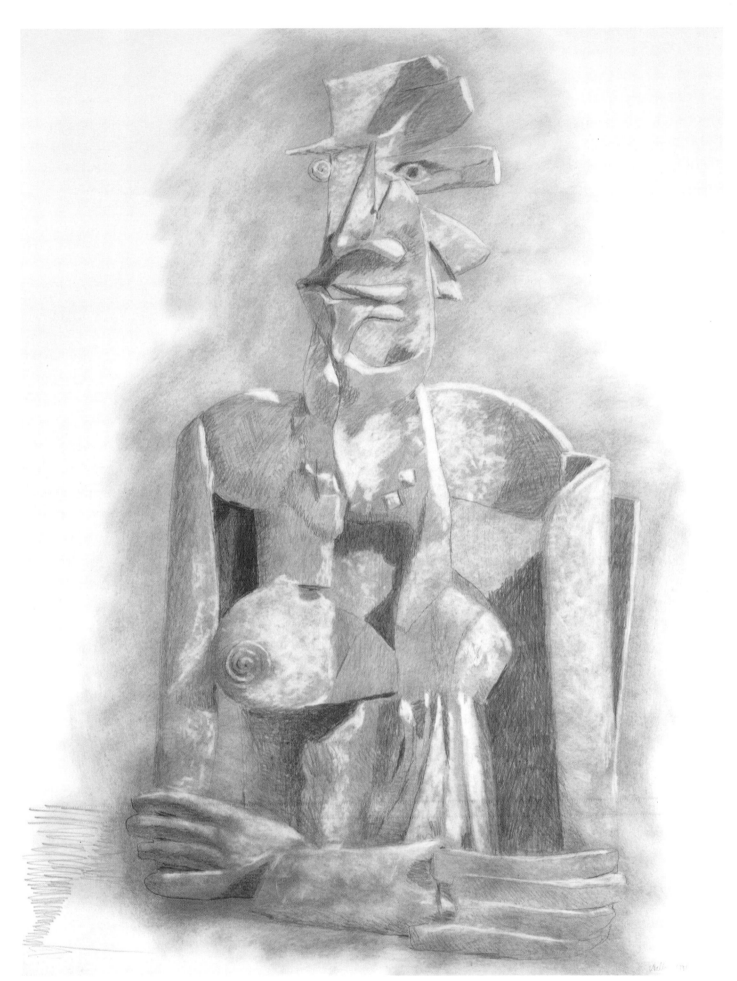

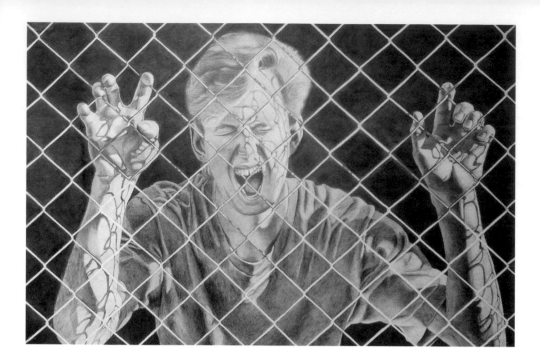

DONNA STALLARD

CPB:TMJ

30" × 44" (76 cm × 112 cm)

Graphite

The artist sets up a contrast between the even, visual rhythm of the wire fence and the exaggerated expression on the figure's face. Also, notice how the regular pattern of the fence turns into a more irregular-

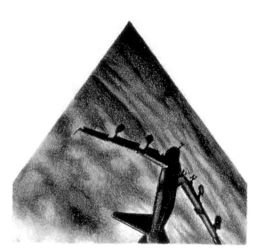

KAY RUANE

Untitled #12

11" × 7" (28 cm × 18 cm)

Pencil on paper

In many of her drawings, Ruane alters her format to include non-rectangular shaped pieces of paper along with rectangular ones.

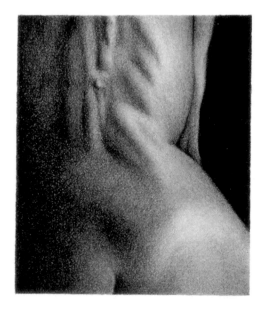

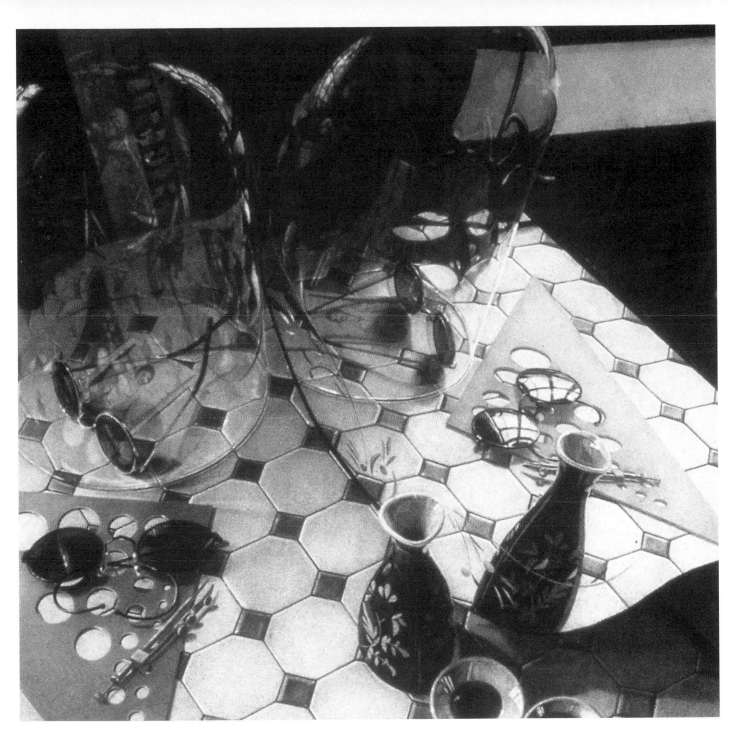

STEPHEN FISHER

Déja Vu

21" × 21" (53 cm × 53 cm)

Charcoal, graphite, and wash on hot-pressed watercolor paper

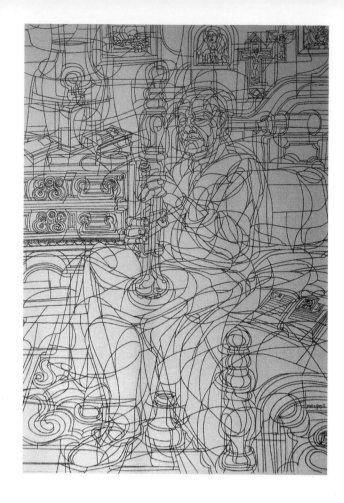

JOSEPH E. GREY II

Old Man Blue

22" × 16" (56 cm × 41 cm)

Pen and ink on watercolor paper

The continuous lines in this drawing act symbolically, connecting the musician to all of the objects that surround him.

MARK WORKMAN

Dark Spring

40" × 60" (102 cm × 152 cm)

Black ink and sepia ink, charcoal, and pastel on cold-pressed watercolor paper

The highlights in this work were achieved by scraping away black pastel and charcoal from the paper.

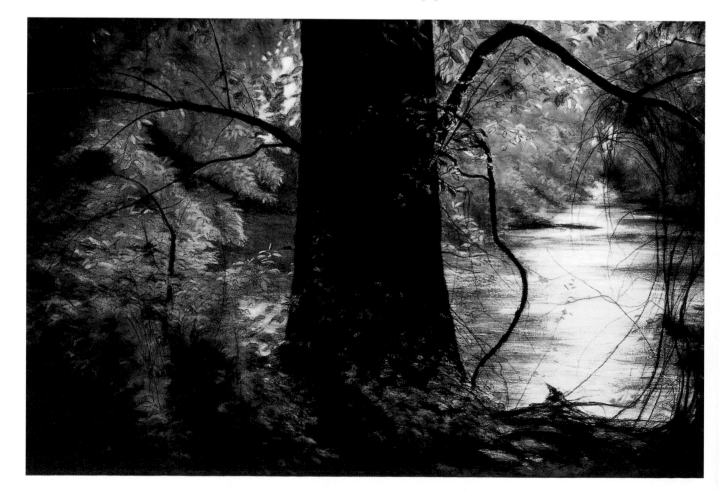

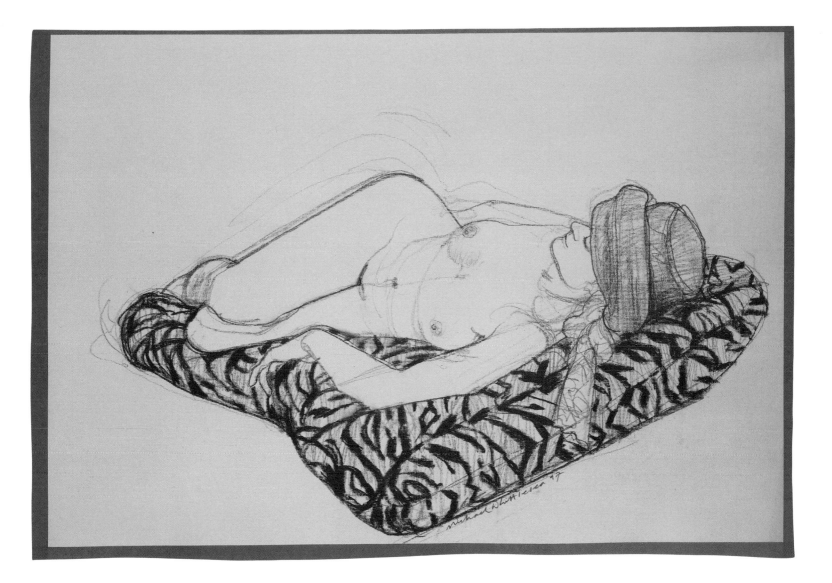

MICHAEL WHITTLESEA

Nude

18" × 27" (46 cm × 69 cm)

Pencil on paper

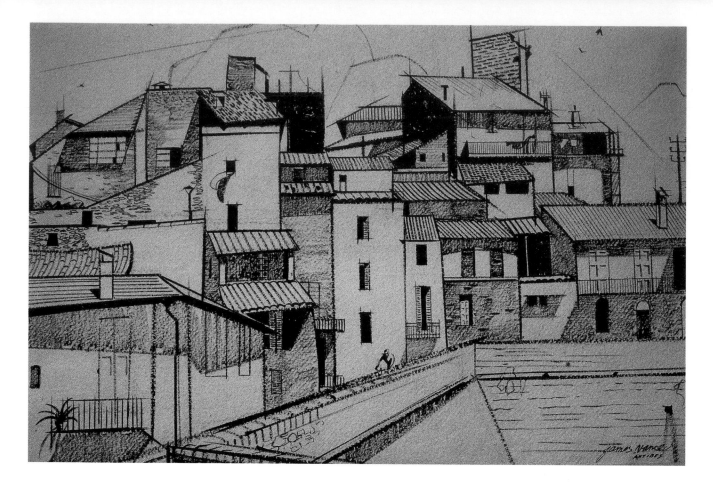

JAMES VANCE

Antibe #2

14" × 22" (36 cm × 56 cm)

Pen and india ink on watercolor paper

Despite the piling up of rectangular forms to depict this apartment complex, Vance's treatment remains interesting by carefully studying his subject and not oversimplifying it.

DEDE COOVER

Shadow Forms

27" × 25" (69 cm × 64 cm)

Pen and ink on watercolor paper

Coover creates an abstract sketch using shadows cast on her terrace as her reference point.

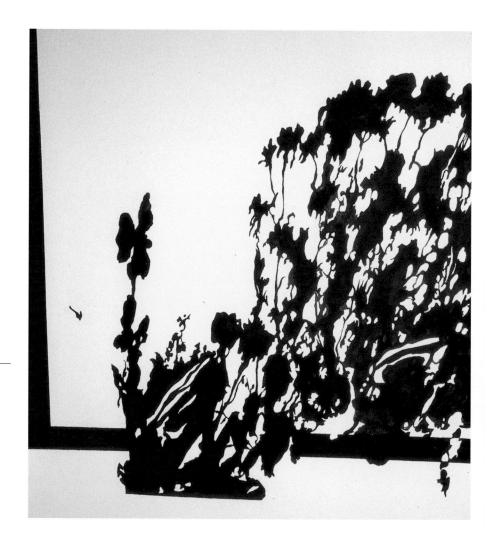

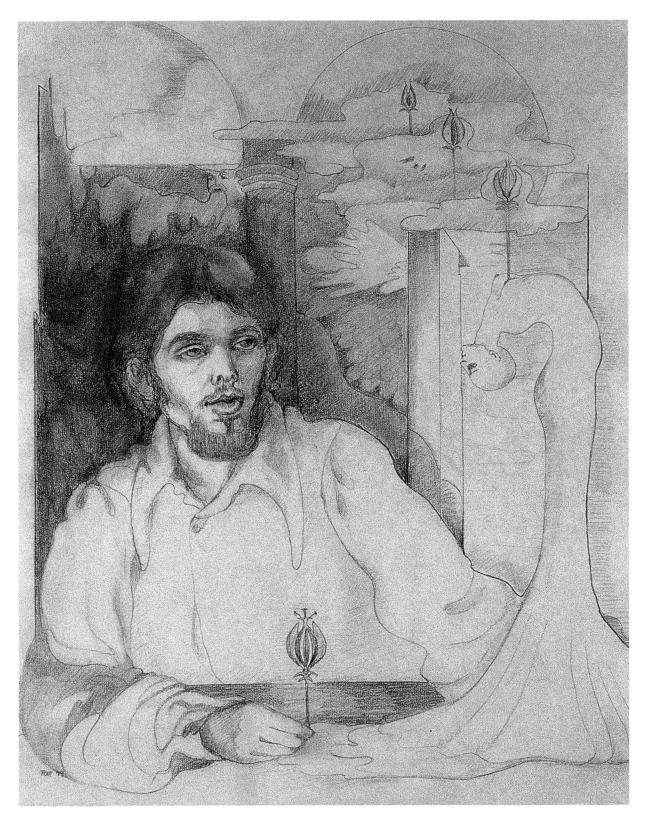

RUTH PLATNER

Magic

20" × 18" (51 cm × 46 cm)

Pencil on paper

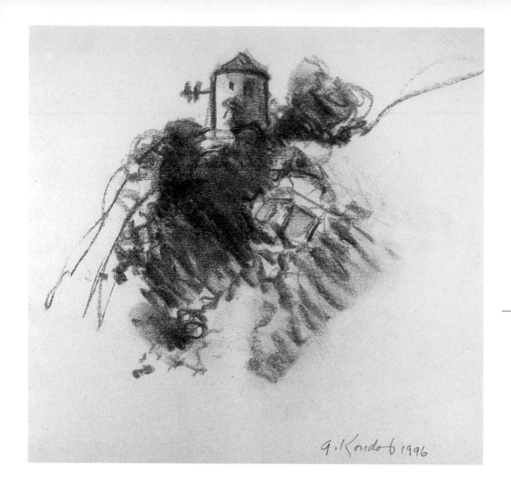

Gregory Kondos

Windmill, Hydra Greece
8" × 7" (20 cm × 18 cm)
Charcoal on paper

Patricia Watwood

Figure Study
10" × 14" (25 cm × 36 cm)
Pencil on paper

The figure in this drawing is made up of hatchings and cross-hatchings to build up the tone and create a sense of volume.

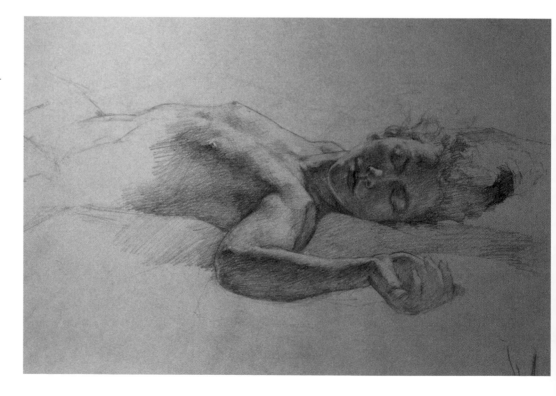

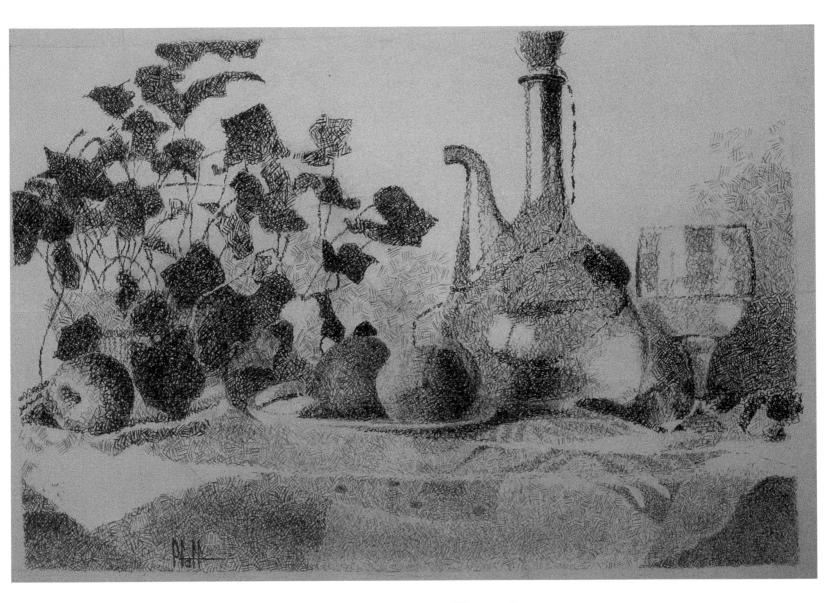

WILLIAM PFAFF

Peaches and Wine Still Life
11" × 15½" (28 cm × 39 cm)
Pen and ink on cold-pressed paper

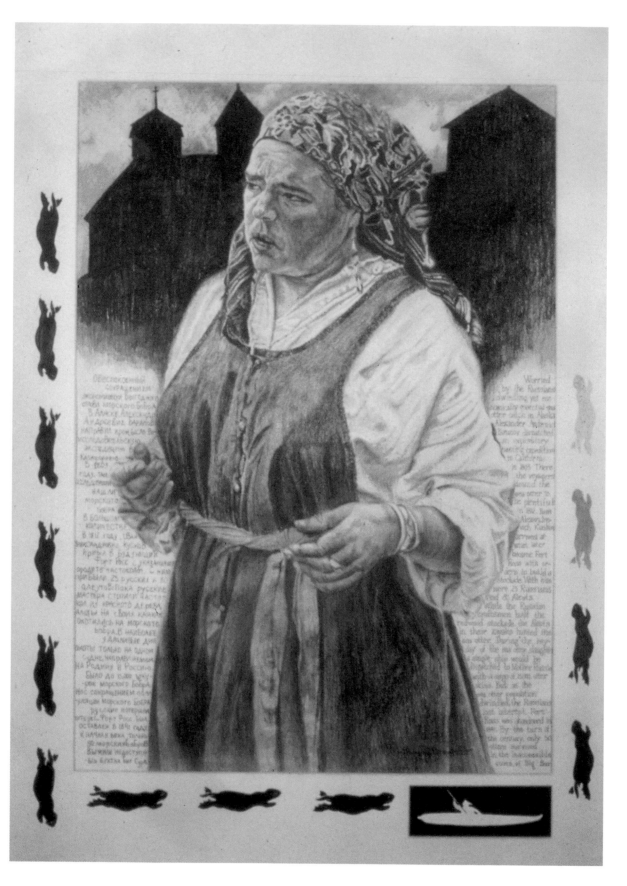

PENNY STEWART

Fort Ross—Sea Otter Tragedy

22" × 30" (56 cm × 76 cm)

Pencil on paper

Freemont Barn I

19" × 24" (48 cm × 61 cm)

Charcoal on paper

The artist has abstracted the form of the barn so much that it is only through the work's title that we still know it is a barn.

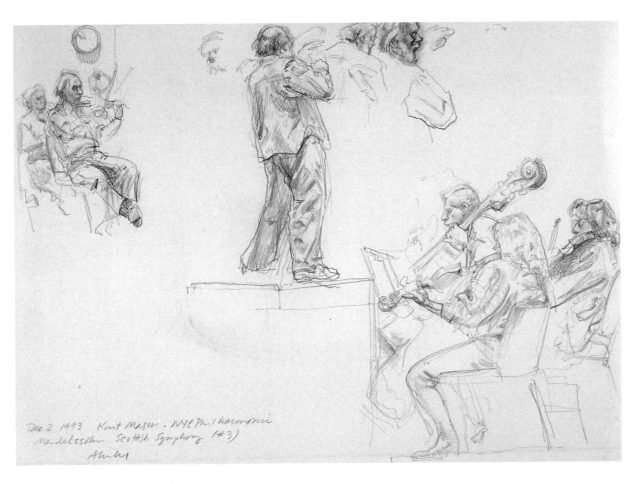

SIGMUND ABELES

The New York Philharmonic in Rehearsal

9" × 12" (23 cm × 30 cm)

Pencil on paper

Like one of his heroes, Edgar Degas, Abeles worked directly from life to capture the visual rhythms of this world-famous philharmonic.

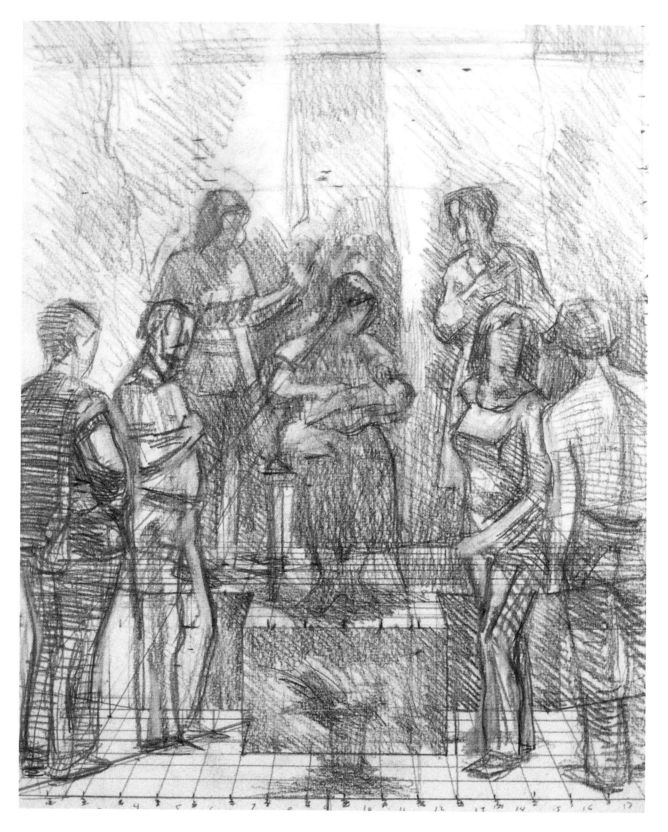

DOMENIC CRETARA

Study for Madonna and Child

9" × 8½" (23 cm × 22 cm)

Pencil on paper

To organize and focus the figures
composition, Cretara uses a triangular
format, which is a traditional Renaissance
pictorial device.

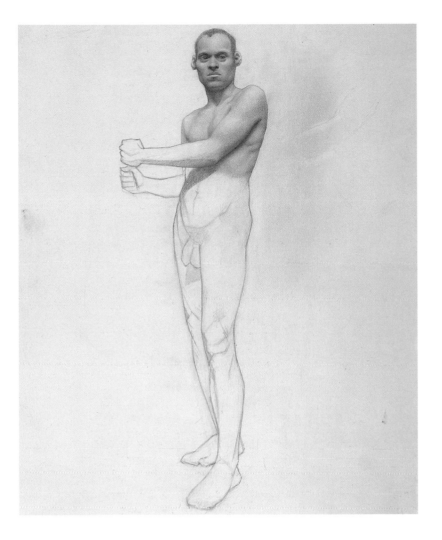

KORÉ YOORS

Nude

24" × 18" (61 cm × 46 cm)

Pencil on paper

MICHAEL KAREKEN

Tornado with Tilted Horizon

55" × 42" (140 cm × 107 cm)

Charcoal on paper

The artist captures the chaos and power of a tornado by using both the charcoal and his eraser in a gestural manner. What is exceptional about this drawing is that despite his gestural use of the charcoal, the image is not obscured by the resulting blurred shapes. This effect, often called sfumato, actually taps into the experience of seeing a twister. He further emphasizes the tumult of the scene by slanting the horizon line.

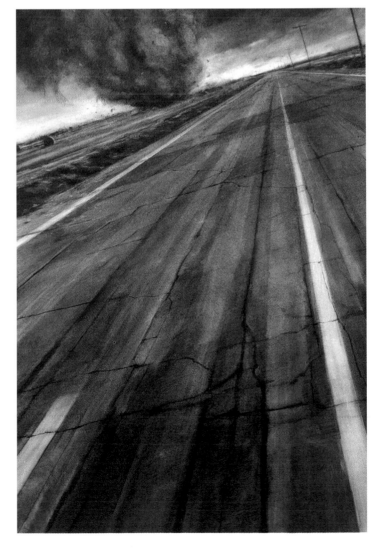

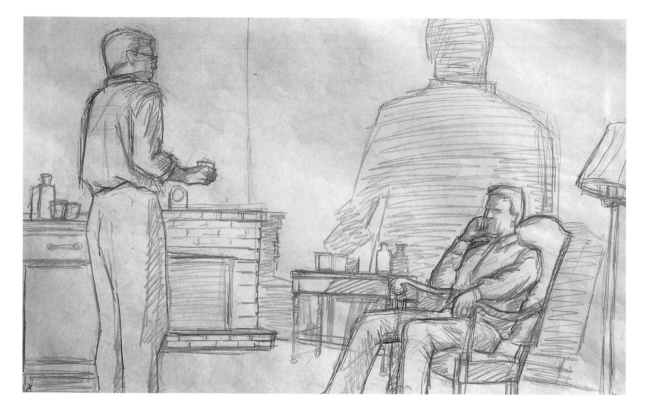

MARY T. MONGE

Pinecone Motel

17" × 11" (43 cm × 28 cm)

Pencil on bond paper

The negative space between the two figures is activated by the shadow on the wall behind the seated figure. In placing the shadow in such a conspicuous place, the artist has made the viewer aware of a light source that exists beyond the borders of the picture, giving the scene a slice-of-life quality.

AMY CHUN

Still Life

23¹⁄₂" × 18" (60 cm × 46 cm)

Charcoal and pencil on paper

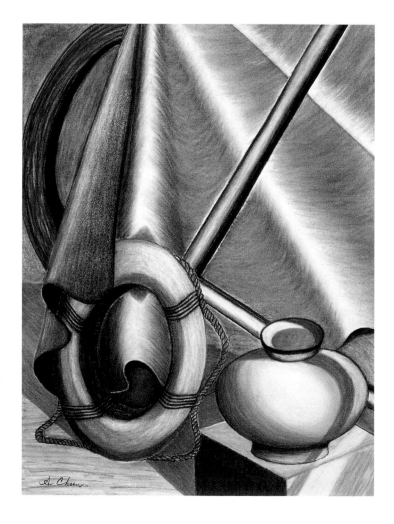

THE East Hampton STAR

SHINES FOR ALL

VOL. CVI, NO. 40 THURSDAY, MAY 19, 1994 EAST HAMPTON, N.Y. SINGLE COPY 85¢

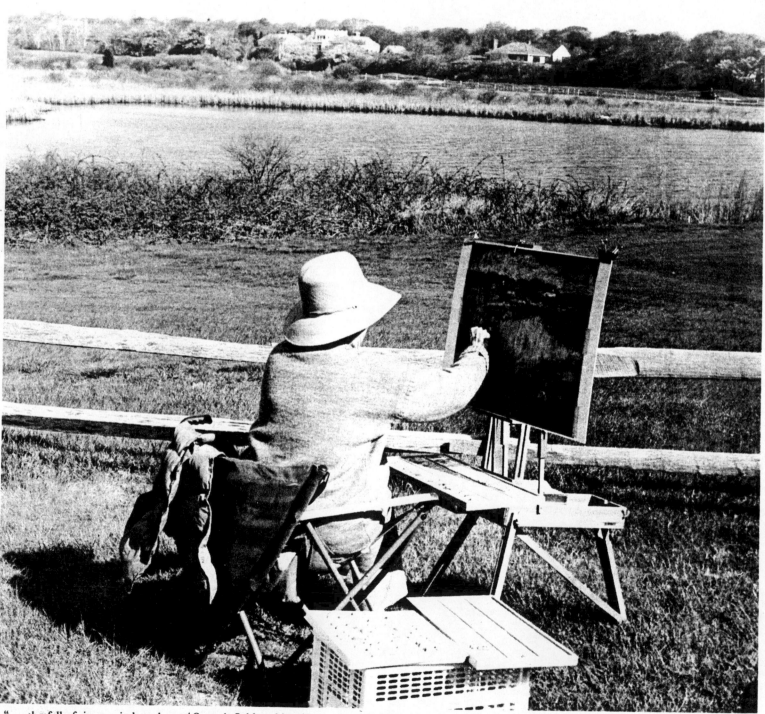

"... the fall of rivers, winds and seas,/ Smooth fields, white sheets of water, and pure sky. . . .": Wordsworth

Morgan McGivern

Kardon's Art Quivers With Gutsy Beauty

BY JANNE HEIFETZ
Special to the BALTIMORE JEWISH TIMES

New paintings by Carol Kardon, Deborah Jones, and Margo Allman at the C. Grimaldis Gallery make up one of the strongest shows Baltimore has seen for a long time.

Carol Kardon, who has had numerous exhibitions on the East Coast, is the most traditional painter of the three. Her romantic-impressionistic landscapes have a gutsy beauty that makes them eminently satisfying. Her solid sense of composition is apparent in the monumental quality of her work, and her fine coloristic sense instills it with a freshness and vigor that one rarely sees in contemporary landscape painting.

Hay Bales is a luminous, uplifting work. Bales of hay in the foreground lead our eyes back to the deep greens and purples of the hills behind. The sky contains a subtle range of colors that suggest infinite depth. A huge, shadowed hay bale at the lower right is made up of more colors and brushstrokes than one can imagine in such an object, and the form itself quivers into life. The eight bales of varying dimensions seem to populate the landscape with an animus all their own.

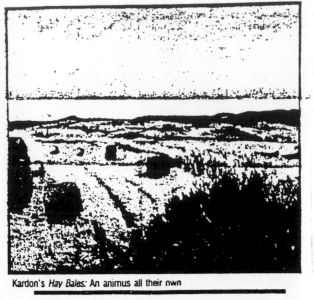

Kardon's *Hay Bales:* An animus all their own

Carol Kardon
Kimberton Gallery
Chester County
Sept 9 - Sept 30

Carol Kardon uses painterly, unrestrained brushwork, and the suffused intensity of yellow daylight in her oil painting "A Sunday Morning," in the tradition of the California Society of Six colorists. The canvas vibrates with energy in a tapestry of color units and her unmodulated colors, rich and dazzling, are chosen for the effect of jeweltones rather than to label.

Kardon sees shadows as variations of color in the manner of the Impressionists but she has a way of grounding and outlining some of her figures with red which gives them a unique glow. "South Pasture," a large oil painting with cows, is not just another bucolic scene; the energetic intensity of her brushwork contrasting with the static, rock formation-like composition of the assembly of cows and the atmospheric suffusion of light is distinctive.

A pastel work called "The Red Roofs" is a minimalist geometric close-up of roofs and barn sides which combines simplicity with the contrast of a pulsating fire-engine-red roof and the subtle shading of darks on the siding. This dramatic work is all straight lines and angles which could be tedious except for one subtly curved, beautifully placed line that softens the over-all effect.

Diana Roberts

Gannett TODAY/Friday, March 26, 1981

By KATHIE BEALS

A dark and dreamy pastel that instantly calls to mind Claude Monet's "Water Lilies" is on view at The Kiva gallery in Scarsdale.

Three years ago it would not have been there. The mood then was a kind of cocky extravagance, cheerfully avant-garde and determined to surprise. Exhibitions centered on fiber craft as art — tapestries that glittered, costumey crochet buried in beads, tiny caricature sculptures. Pop art for expensive tastes.

Less than two years ago The Kiva began to change directions and the current show is an interesting example of how far the pendulum has swung to the right. The gallery is no longer a champion of craft; it is now a believer in the eternal verities of fine art, that is, painting and sculpture.

Carol Kardon, whose pastel, "Sand Bar," recalls Monet and Impressionism, is showing only a few pictures in this medium, but what there is, is a colorist's triumph. She brings to landscape art a new way of using the colors that exist in nature, setting them off in a way that that produces a subdued and velvety glow that invites the eye to return again and again.

The same artist's oil paintings are landscapes, also, but the landscape seems almost in motion, as if it were some powerful force of nature threatening to smother a house that stands in its way.

Carol Kardon
"Echoes of Normandy"
Kimberton Gallery
Thru May 25

Carol Kardon has a new palette – and what a palette it is! Like the difference between a birthday candle and a Roman candle, Kardon's landscapes explode in a sparkle of colors.

Using a Fabriano cotton paper available in France, and shimmery iridescent pastels that give off a metalic sparkle irresistible to the eye, Kardon does not so much recreate the Norman landscape as she translates the *experience* of it into large pastels. Similar in the tone and spirit to the late works of Monet at Giverny, Kardon's bold and watery meld of continuously rippling, harmonious colors evoke a mood.

Intrinsically French also are Kardon's Impressionistic color chords, with the sensuous *joie de vivre* of Fragonard at his best. Kardon's skies are roiling, eddying, broad expanses of color-infused atmosphere that have a life of their very own.

Diana Roberts

Roman candles not birthday candles: One of Carol Kardon's recent pastels, "Top of the Path," was shown at the Kimberton Gallery in May.

SELECTED GROUP EXHIBITIONS

1996	Main Line Art Center-Annual Arts Festival, Haverford, PA
1996	The Millay Colony Preview/Review World Wide Web Site at http://www.millaycolony.org/re_va.html
1996	Ninetieth Annual Open Exhibition, Salmagundi Club, New York, NY
	Tenth Annual International Open Exhibition (Pastel Society of the West Coast), Sacramento, CA
	National Juried Pastel Competition, Pittsburgh, PA
1995	Bryn Mawr College, Bryn Mawr, PA
1994	Conn. Pastel Society Exhibition, Wallingford, CT
1993-94	Caspecken-Scott Gallery, Wilmington, DE
1994	Summa Gallery, New York, NY
1989-94	Neville-Sargent Gallery, Libertyville, IL
1986-87,90-92	Pastel Society of America Annual Open Juried Exhibition, New York, NY
1986-88	Shippee Gallery, New York, NY
1988	Riverwalk Art Exhibition, York, PA
1987	Pastel Society of America Exhibition, Lever House, NY
1986	Contemporary Women Artists of Philadelphia Invitational Exhibit, Wallingford, PA
1985	Zimmerli Art Museum, Rutgers University, New Brunswick, NJ
	Great Swamp XXV Exhibit, Basking Ridge, NJ
	Nabisco Brands Corporation, Invitational Exhibit, East Hanover, NJ
1983	Baltimore Museum of Art Rental Gallery, Baltimore, MD
	Philadelphia Museum of Art Rental Gallery, Philadelphia, PA
1982	Landscape II C. Grimaldis Gallery, Baltimore, MD
	Invitational Benefit for the South Fork, Benson Gallery, Bridgehampton, NY
1981	Flower Painting, Gross McCleaf Gallery, Philadelphia, PA
1980	Contemporary Painting, Park-Bernet, NY
	Cheltenham Award Show, Museum of the Philadelphia Civic Center, Philadelphia, PA

SELECTED PUBLIC COLLECTIONS

Art Overseas
Arthur Anderson
Atlantic Emplyees Federal Credit Union
AT&T
Beth Israel Medical Center
Bryn Mawr College
Carodan Corp.
Centocor Corporation
Cooper Diagnostics Inc.
CoreStates Bank
Federal Mogul
Holister Corp.
Kidder Peabody Co.
Pepsico
R.J. Reynolds Industries
Robert Wood Johnson Memorial Hospital at Hamilton
Rittenhouse Hotel
St. Francis Hospital
Shearson Lehman Brothers
Shell Oil
Signet Art
Smith, Barney, Harris & Upham Co.
Trammell Crow Co.
TWA
Union Bank

CAROL KARDON

248 BEECH HILL RD.
WYNNEWOOD, PA. 19096 610-649-9573

PRESENTLY AFFILIATED WITH:

Summa Gallery, New York, NY
Cooper Gallery, Lewisburg, WV
Neville-Sargent Gallery, Libertyville, IL
Caspecken-Scott Gallery, Wilmington, DE
Member of Salmagundi Club, NY
Member of Pastel Society of America
Member Pastel Society of the West Coast

EDUCATION

Bennington College, B.A., Bennington, VT
Art Students League, NY
Barnes Foundation, Merion, PA
University of Pennsylvania, Graduate School of Fine Arts

ONE PERSON EXHIBITS

1998	Cooper Gallery, Lewisburg, WV
1997	Carspecken-Scott Gallery, Willimington, DE
1996	Neville–Sargent Gallery, Libertyville, IL
1992	Genest Gallery, Lambertville, NJ
1988-91	Kimberton Gallery, Kimberton, PA
1987	Gallery Avenue Kobe, Nishinomiya Hyogo, Japan
1986	Decker Gallery, Greenwich, CT
1984	Gross McCleaf Gallery at Hahnemann University, Philadelphia, PA
1983	C. Grimaldis Gallery, Baltimore, MD
1981	Kiva Gallery, Scarsdale, NY
1980	Gross McCleaf Gallery, Philadelphia, PA

GRANTS AND AWARDS

1999 INCLUDED IN BEST OF SKETCHING & DRAWING, ROCKPORT PUB, ROCKPORT, MA.
1999 ANNUAL EXHIBITION SALMAGUNDI CLUB, N.Y.C. WM. ALFRED WHITE MEMORIAL
1998 THUMB-BOX EXHIBITION-SALMAGUNDI - MARTIN HANNON MEMORIAL AWARD

1996	Marion Strueken–Bachmann Award from the Pastel Society of America
1996	Pastel Society of America Award, Salmagundi Club 19th Annual Exhibition
1996	Pastel Society of the West Coast, 10th Annual International Open Exhibition
1996	Canson-Talons Award
1996	Included in *Best of Pastel*, Rockport Publishers, Rockport, MA
1994	Saint John Pastel Award, Conn. Pastel Society
1992-93	Pew Foundation Grant
1993	Listed in Who's Who in American Art
1990	Kramer Memorial Award, 53rd Annual Professional Members Exhibition, Main Line Center of the Arts, Haverford, PA
1988	Antonelli Institute Award, Riverwalk Exhibition, York, PA
1987	London Memorial Award, 50th Annual Professional Members Exhibition, Main Line Center of the Arts, Haverford, PA
1985	Contemporary Women Artists 1985 Calendar, Palo Alto, CA
1983	Rosenfeld Award, Cheltenham Award Show, Cheltenham, PA
1979	Millay Colony for the Arts, Austerlitz, NY
1979	Full Membership-Pastel Society of America
1978	Hambidge Center, Rabun Gap, GA
1977	Artists for the Environment, Delaware Water Gap, NJ

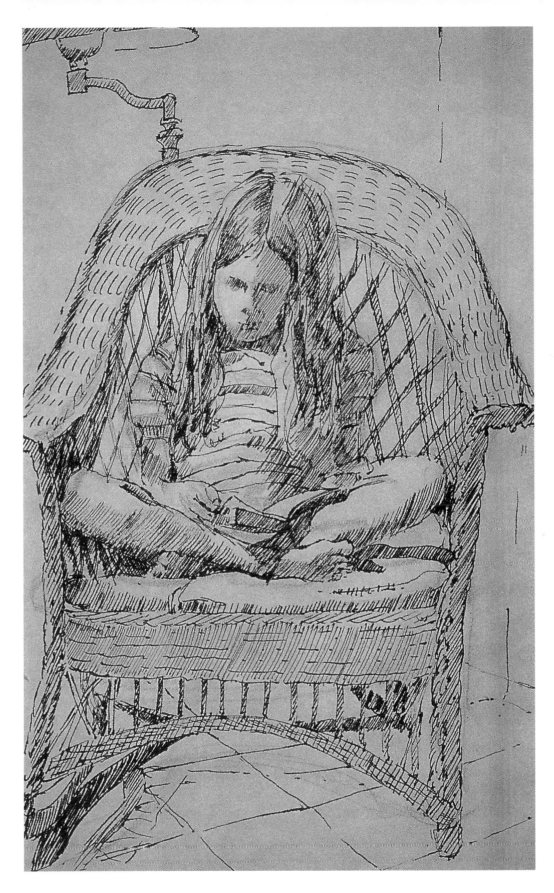

CAROL KARDON

Gabrielle Reading

8" × 5" (20 cm × 13 cm)

Pen and ink on paper

The diagonal cross-hatching provides a
rhythm that unites the entire composition.

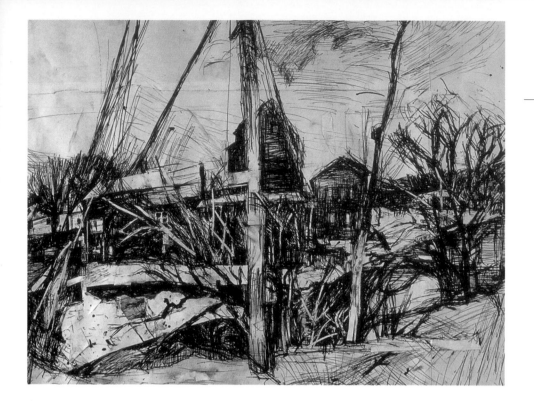

STANLEY LEWIS

Vermont Studio Center—Winter 1997
22" × 28½" (56 cm × 72 cm)
Pen and ink on paper

RHODA YANOW

The Wool Scarf
14" × 11" (36 cm × 28 cm)
Pencil on clayboard

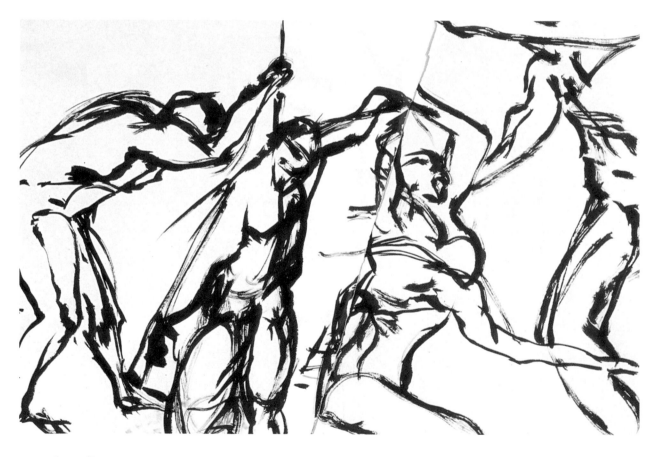

JANE CULP

Figure Composition with Diagonal Tear
18" × 26" (46 cm × 66 cm)
Brush and ink on vellum

This drawing depicts models standing for
thirty-second poses. Because of the time
constraints, the artist is forced to set
down only the most essential marks.

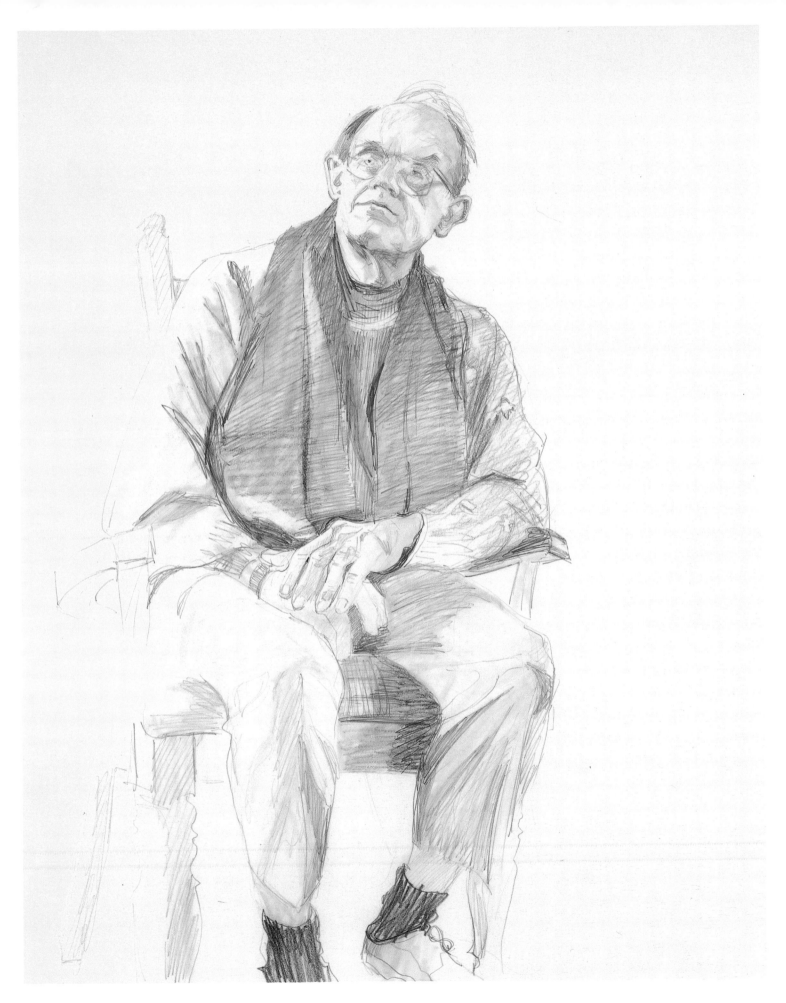

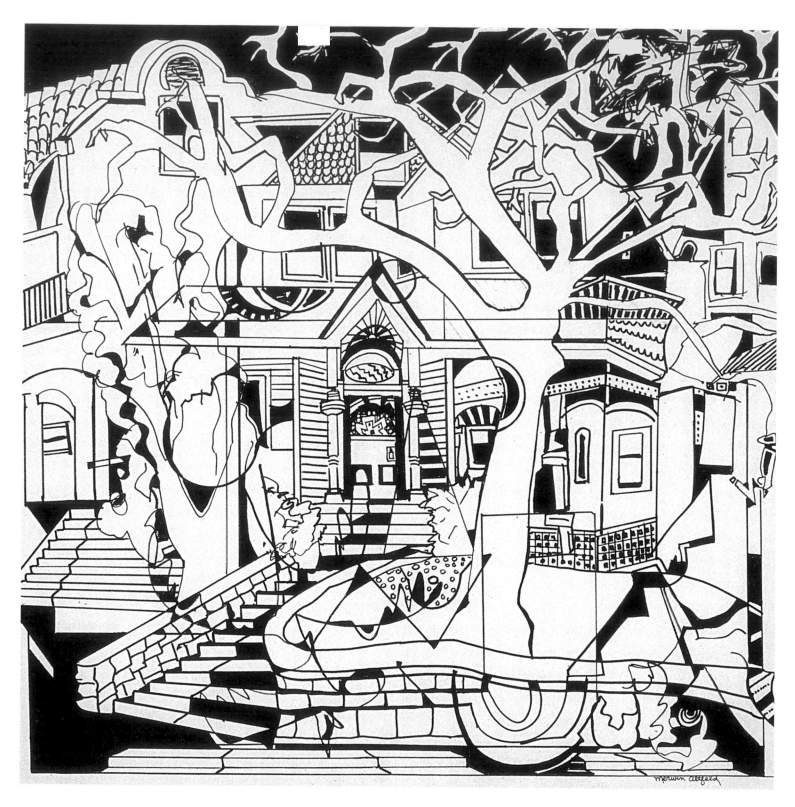

MERWIN ALTFELD

Victorian House

20" × 20" (51 cm × 51 cm)

Pen and ink on board

GEORGE BOBRITZKY

Artist Yasuo Kuniyoshi

18" × 14" (46 cm × 36 cm)

Brush-and-ink wash

With a few deft brushstrokes, Bobritzky has not only captured the subject's facial features, but has expressed his mood.

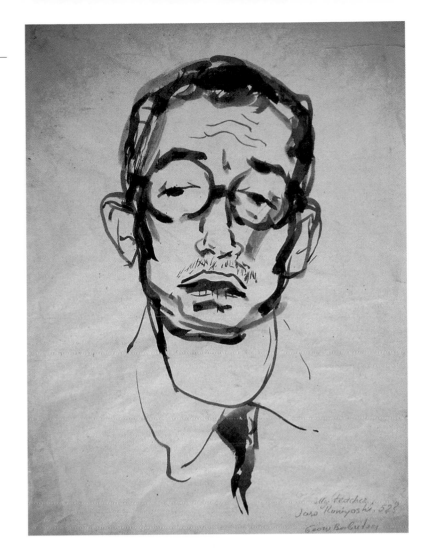

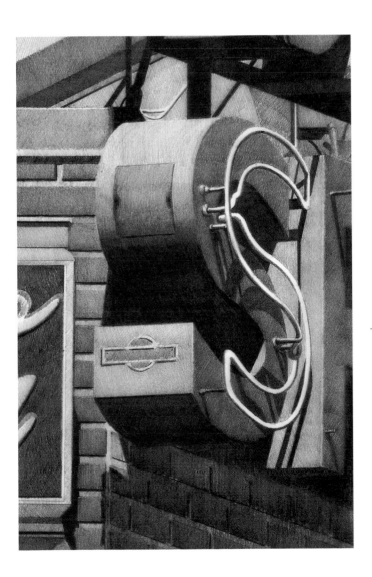

ROBERT COTTINGHAM

S

13½" × 8¾" (34 cm × 22 cm)

Pencil on vellum

Instead of having the lines of perspective converge, which is the most common way of depicting objects in space using perspective, Cottingham used parallel lines to better organize the composition of this drawing. For example, the diagonal lines of bricks, in the lower right-hand corner of the picture, are all parallel and do not converge to a vanishing point.

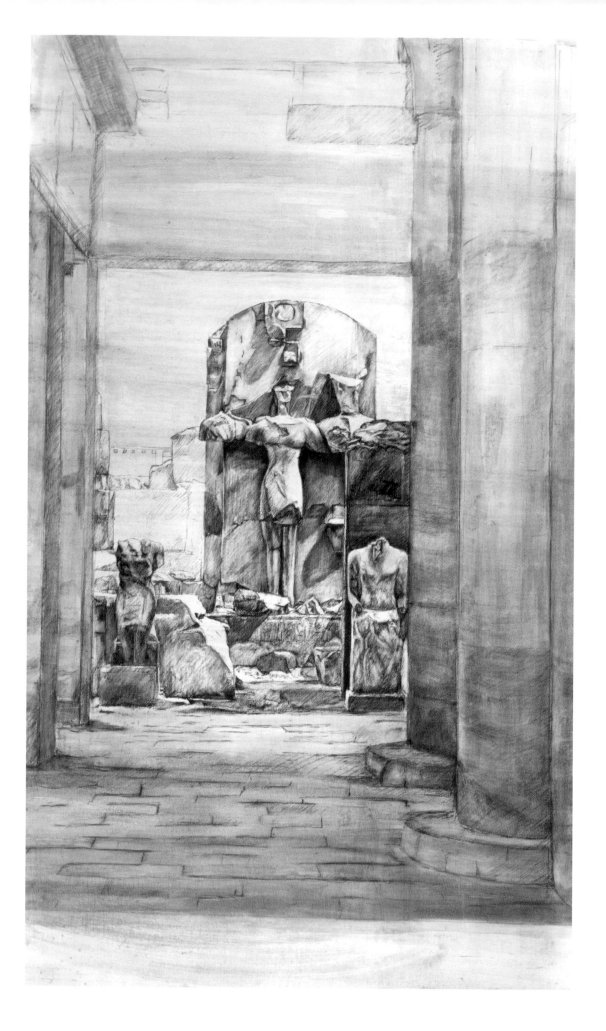

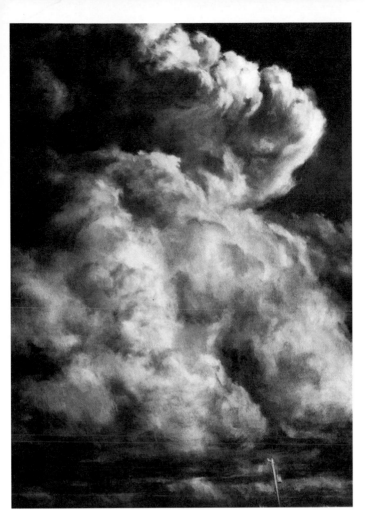

MICHAEL KAREKEN

Storm Clouds

60" × 42" (152 cm × 107 cm)

Charcoal on paper

Kareken's drawings of clouds call to mind the great drawings and paintings of the English artist, John Constable, who ceaselessly studied and depicted cloud formations at various hours of the day. But whereas Constable's aim was scientific in spirit, Kareken's goal is more emotional.

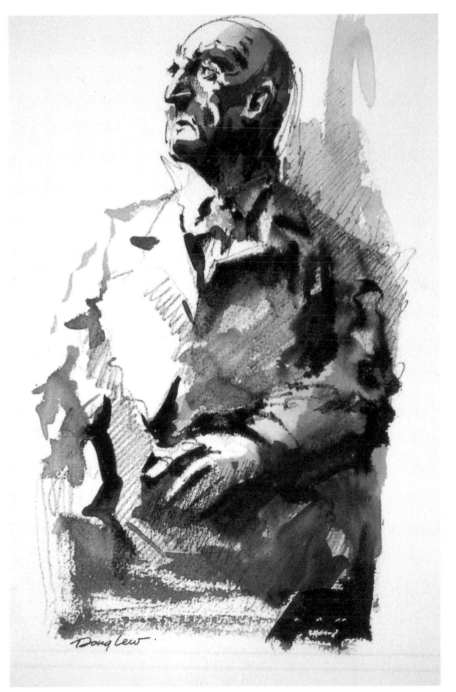

JANE SUTHERLAND

Egypt II

56" × 36" (142 cm × 91 cm)

Pumice gel on paper

Sutherland created this work after a trip to Egypt.

DOUGLAS LEW

Statue of Anton Bruckner-Comoser

18" × 9" (46 cm × 23 cm)

Pen and ink on cold-pressed watercolor paper

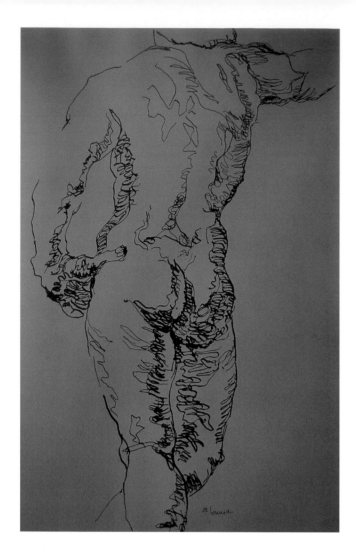

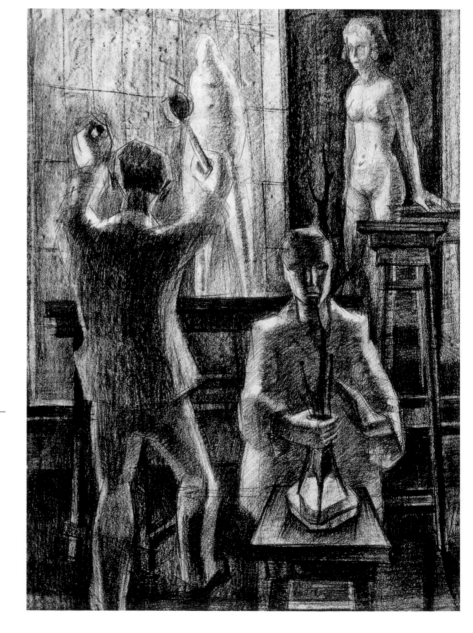

ROBERT LAMELL

Olympian

24" × 18" (61 cm × 46 cm)

Pen and ink on paper

JO SHERWOOD

The Attempt

18" × 24" (46 cm × 61 cm)

Charcoal on paper

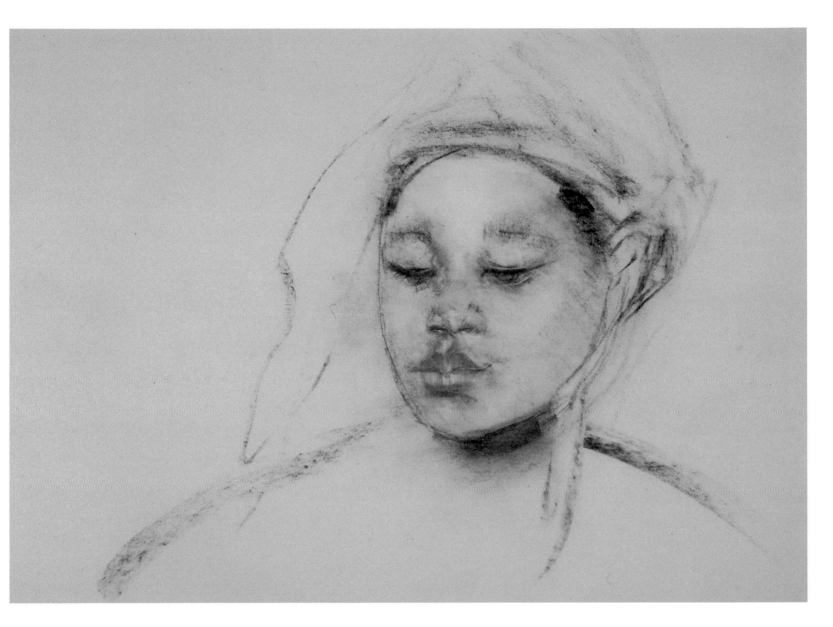

PEGGY TRULL

Quean

16$\frac{1}{2}$" × 18" (42 cm × 46 cm)

Charcoal on Chinese paper

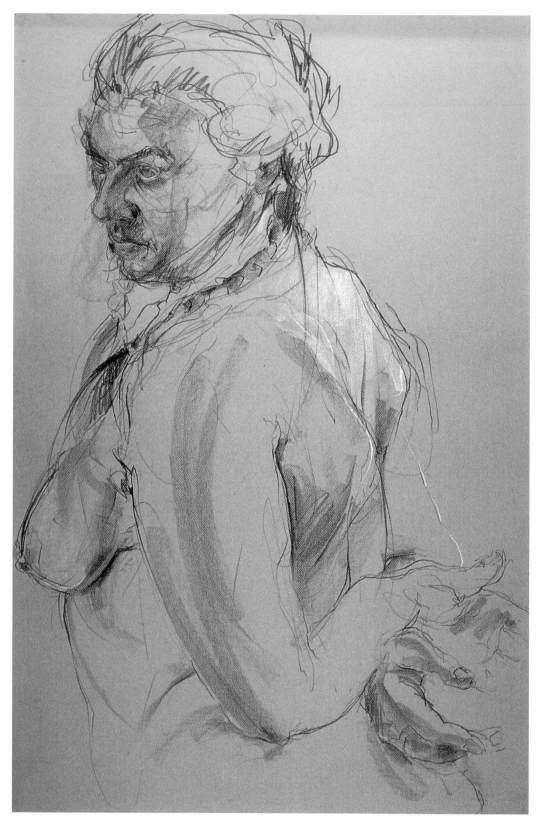

BARBARA FUGATE

Lucia

43" × 29¹/₂" (109 cm × 75 cm)

Charcoal and white chalk on gray paper

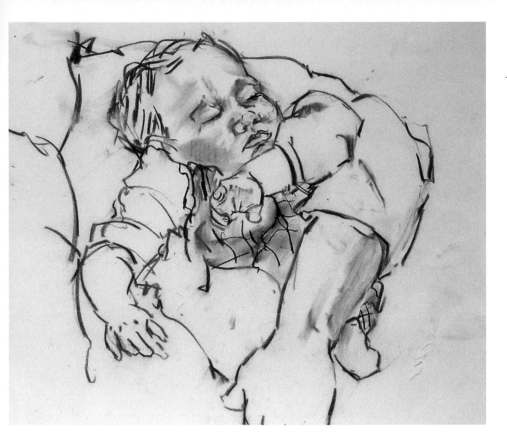

ROBERT GIRANDOLA

Emma

14" × 16" (36 cm × 41 cm)

Charcoal on paper

This drawing depicts the artist's daughter.

DONALD RESNICK

Secluded Wood

11" × 15" (28 cm × 38 cm)

Pencil on paper

In his drawings, which he creates from his imagination, Resnick distills the memory of a scene or location. This particular work refers to a landscape in Long Island, New York.

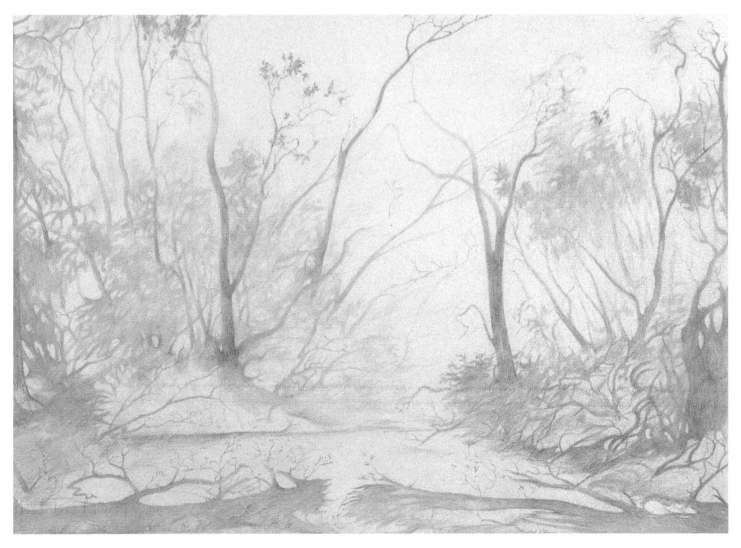

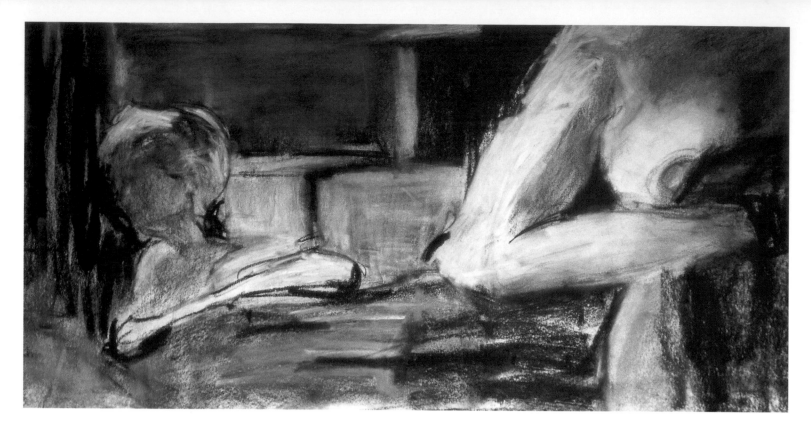

PAMELA WALKER HART

Two Women

11" × 23" (28 cm × 58 cm)

Charcoal on paper

RACHEL KENNEDY

Untitled

8" × 10" (20 cm × 25 cm)

Pen and ink on watercolor paper

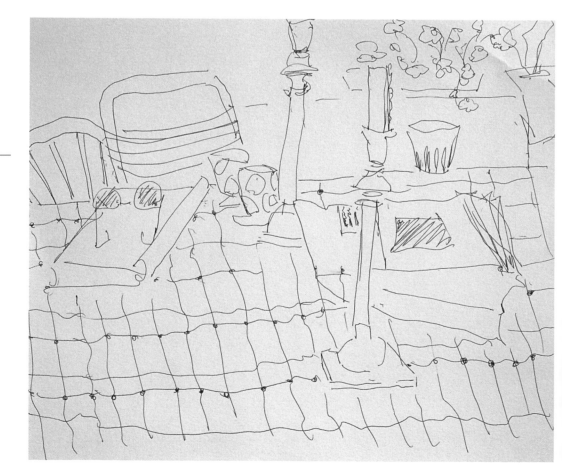

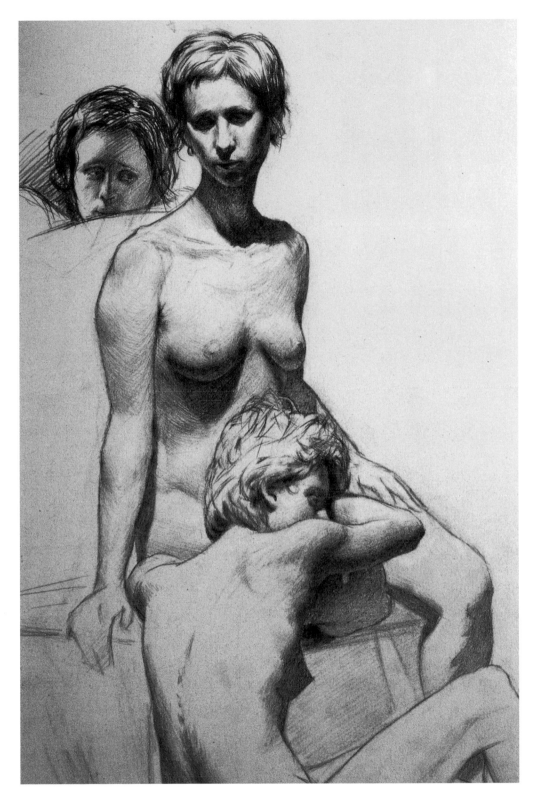

TIMOTHY STOTZ

Liptic Seven (detail)

18" × 13" (46 cm × 33 cm)

Pencil on Arches text-laid paper

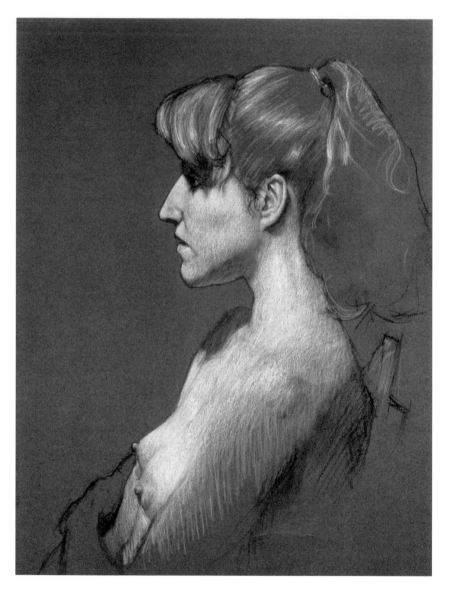

PETER SELTZER

Nude Profile

25" × 19" (64 cm × 48 cm)

Charcoal and white conté on toned paper

JILL MACKIE

Tuber Rose

22" × 15" (56 cm × 38 cm)

Colored pencil on paper

The tradition of drawing flowers from life extends at least as far back as the Renaissance with artists such as Leonardo da Vinci and Albrecht Dürer. For Mackie, these drawings represent portraits of unique, individual, fleeting objects.

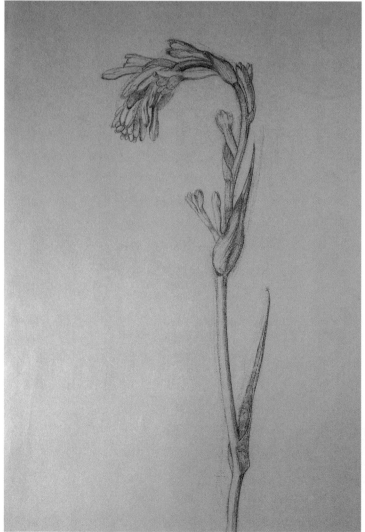

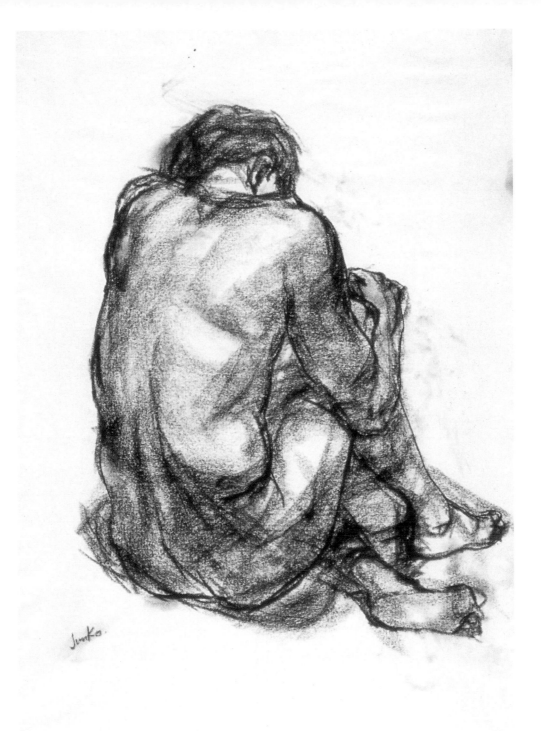

JUNKO ONO ROTHWELL

Resting

23" × 16" (58 cm × 41 cm)

Charcoal on paper

The artist seems to carve the figure out of the paper by using the broadside of the charcoal stick. Where he wants to add emphasis or weight in the figure, he uses line.

117

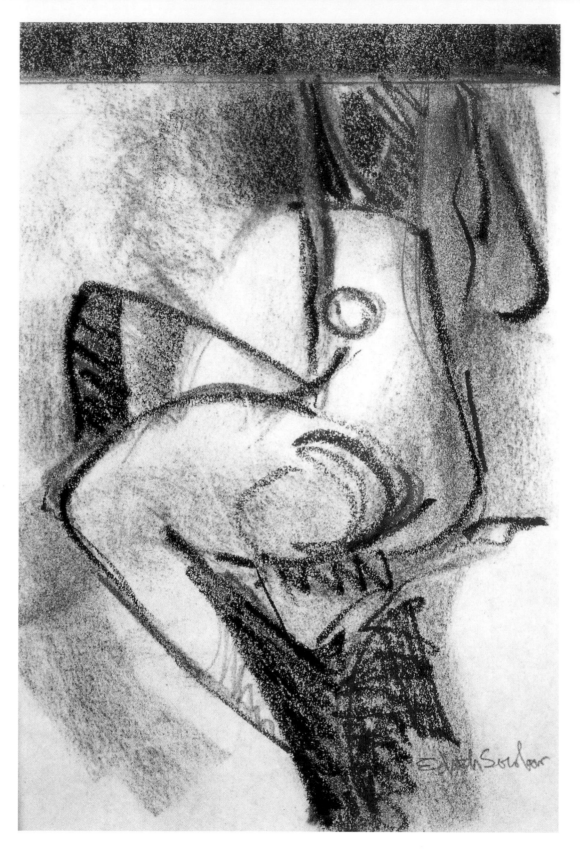

EDITH SOCOLOW

Abstract Nude I

9" × 12" (23 cm × 30 cm)

Charcoal, pencil, and colored chalk on
charcoal paper

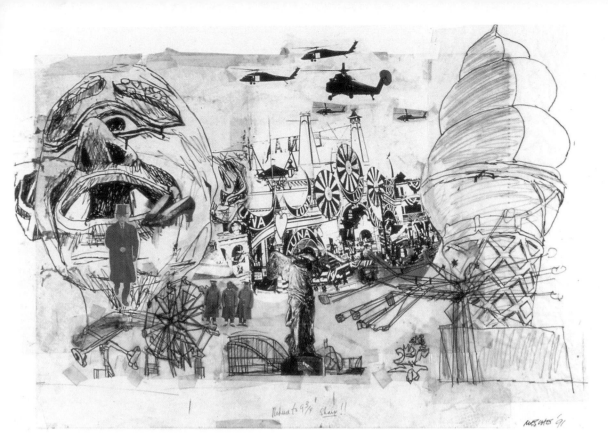

Arnold Mesches

Study for Winged Victory

30" × 40" (76 cm × 102 cm)

Mixed media

Mesches most recent work has been fueled by the sociopolitical concept of moral decay. This work, which was a study for a large mural for his "Anomie" series, incorporates pencil drawings, pen and ink sketches, photocopies, and photographs.

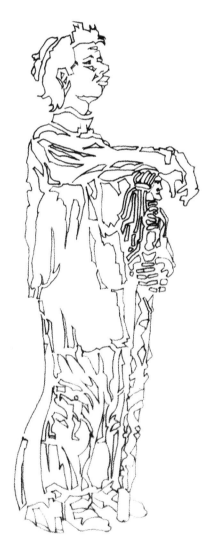

Edward L. Willimon

Poise

11" × 5" (28 cm × 13 cm)

Pen and ink on paper

Willimon uses a contour line to define this figure, outlining seemingly random parts of the body. The result is that some of the areas, such as the face, remain representational while other parts become abstract designs.

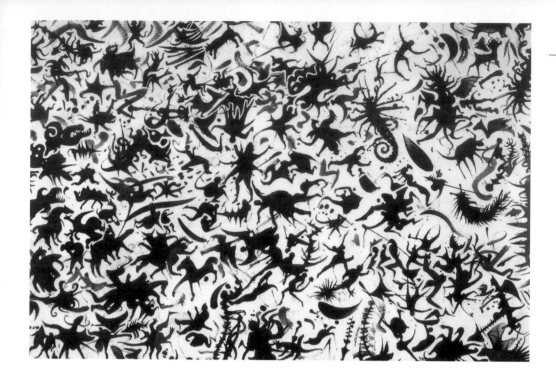

MICHAEL FRARY

DNA Mix-up

22" × 30" (56 cm × 76 cm)

Stick and ink on cold-pressed paper

Using a technique popular with the
Abstract Expressionists of the 1940s and
1950s, Frary derived the forms in this
drawing by dripping a drop of ink on the
paper and developing a form by pushing
the ink around with the opposite end of
his paintbrush.

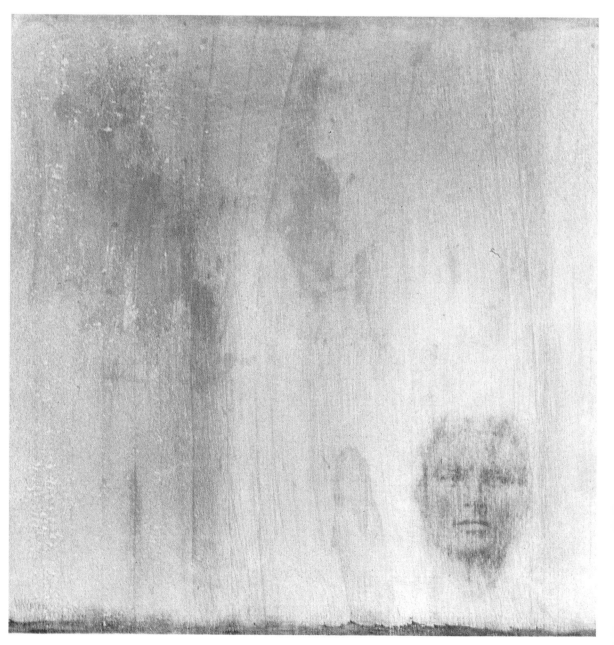

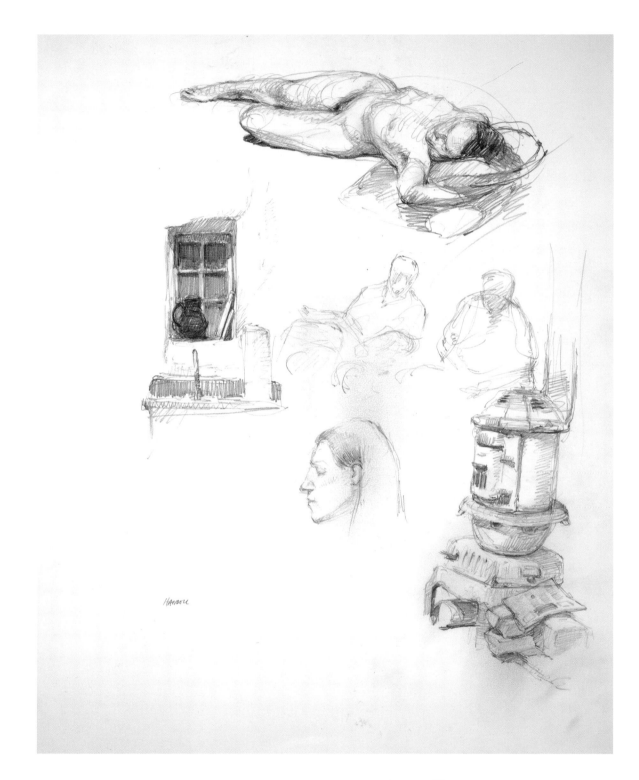

ALBERT HANDELL

Monday-Evening Sketch Class
17" × 14" (43 cm × 36 cm)
Pencil on board

JEFFREY HAYMAN

Jon
6" × 6" (15 cm × 15 cm)
Silverpoint on basswood panel

Backview of a Woman—Boston Market
18¹/₂" × 12" (47 cm × 30 cm)
Pencil on vellum

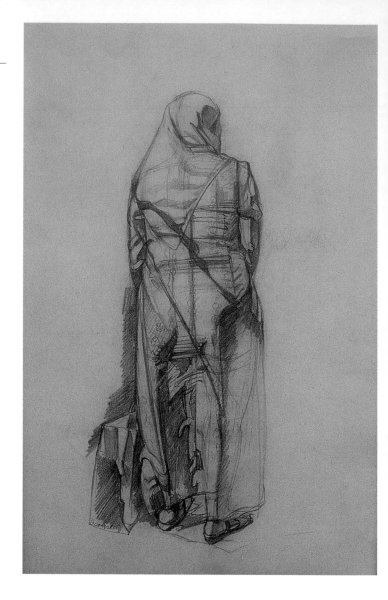

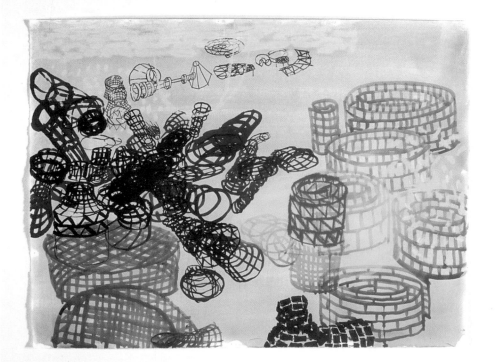

KIRSTEN WESTPHAL

Untitled
20" × 27" (51 cm × 69 cm)
Colored ink, pastel, and sumi ink
on paper

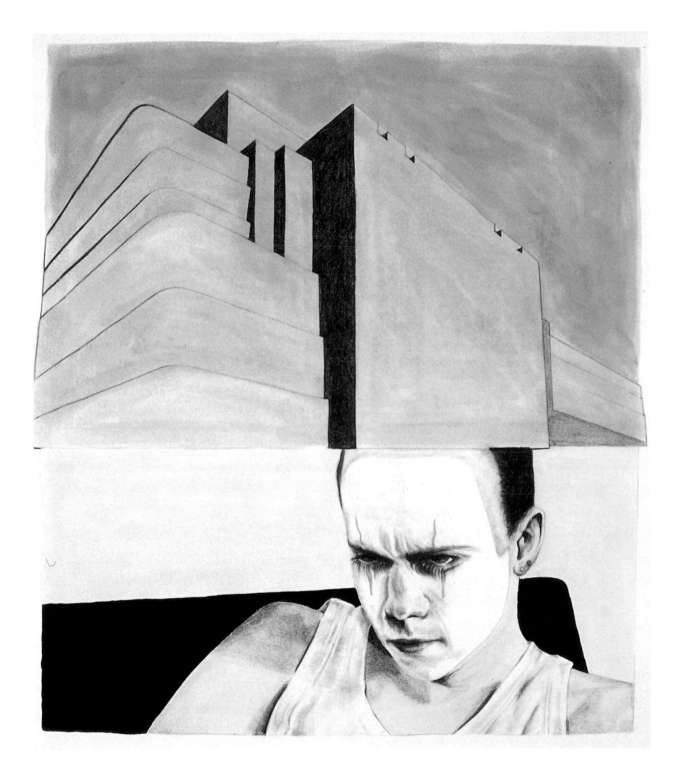

ROBERT LONGO

Study for Pressure
38¹/₄" × 29¹/₄" (97.2 cm × 74.3 cm)
Charcoal, graphite, and acrylic on paper

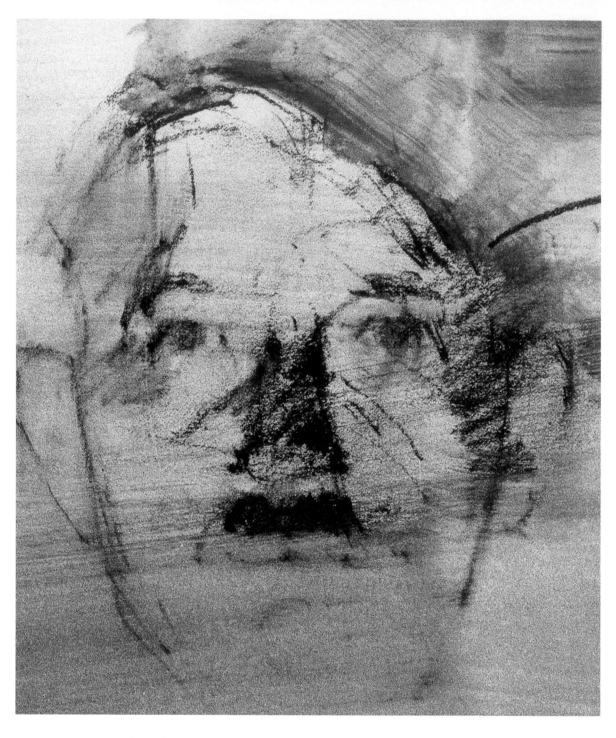

ALEX POWERS

Hitler

16" × 12" (41 cm × 30 cm)

Charcoal and gouache on illustration board

In this portrait of one of the most notorious figures of the twentieth century, Hitler, who was himself an artist, appears like an apparition on the toned paper. Compositionally, Powers has used bottom-lighting of the face to give an ominous quality to the drawing. This can be seen most clearly in the depiction of the nose, in which the bottom part is lighted, while the upper part is cast in shadow.

ROBERT C. THERIEN JR.

Greenhouse Interior–Gazing Globes and Fruit Basket

32" × 23" (81 cm × 58 cm)

Pencil and powdered graphite on illustration board

In this carefully rendered drawing, the artist has captured the reflective qualities of metal and glass.

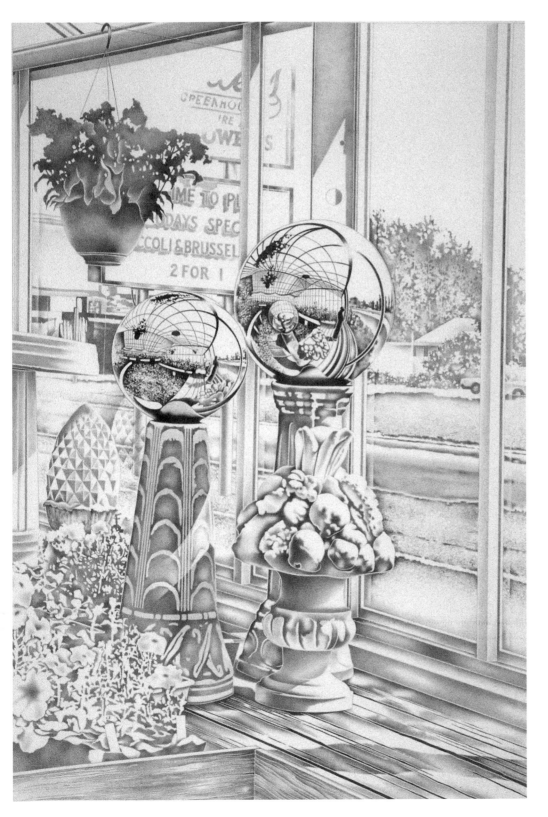

DEBORAH NIETO LEBER

Untitled

19" × 11" (48 cm × 28 cm)

Charcoal on paper

Artists on the Equator

9" × 12" (23 cm × 30 cm)

Pencil on paper

This work is a sketch that the artist created during World War II, when he was in the Air Force and stationed on an island in the Pacific Ocean.

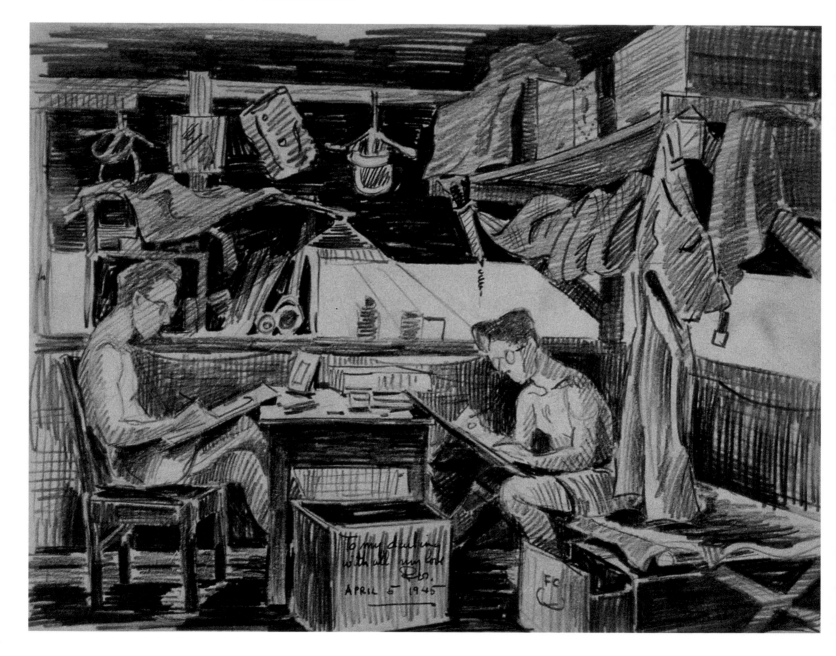

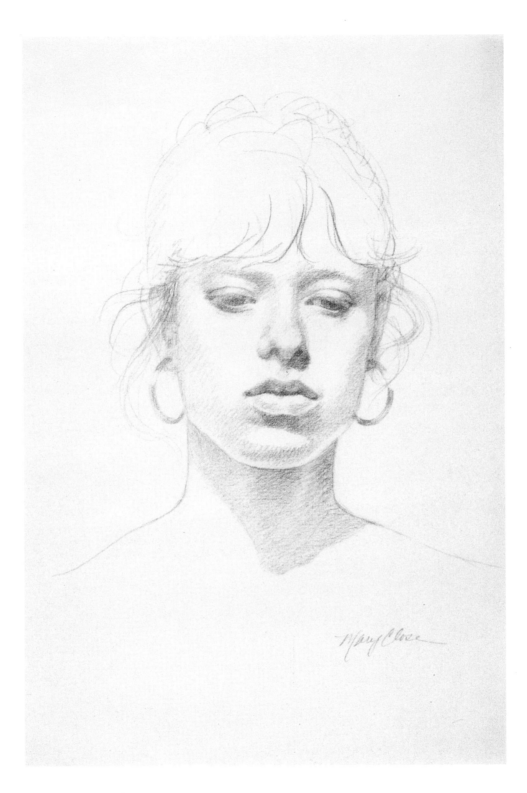

MARY CLOSE

Angel
12" × 8" (30 cm × 20 cm)
Pencil on paper

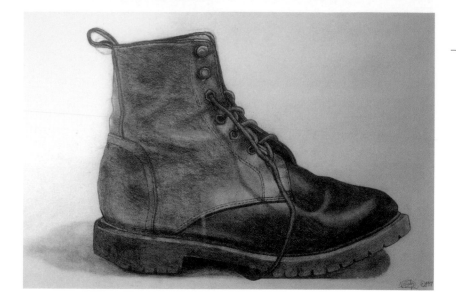

KRISTEN L. TEMPLE

Boot

12" × 18" (30 cm × 46 cm)

Pencil on vellum

RUTH COCKLIN

One-minute Pose

18" × 24" (46 cm × 61 cm)

Conté crayon on paper

The artist uses the weight of the line to depict the volume and weight of the figure.

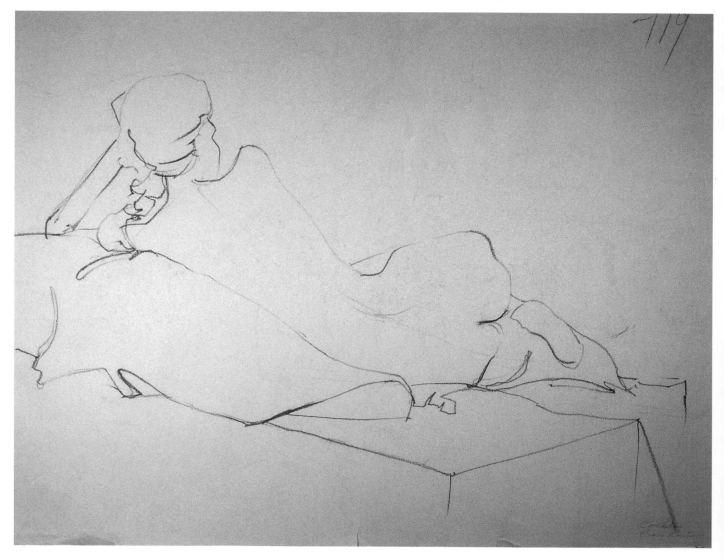

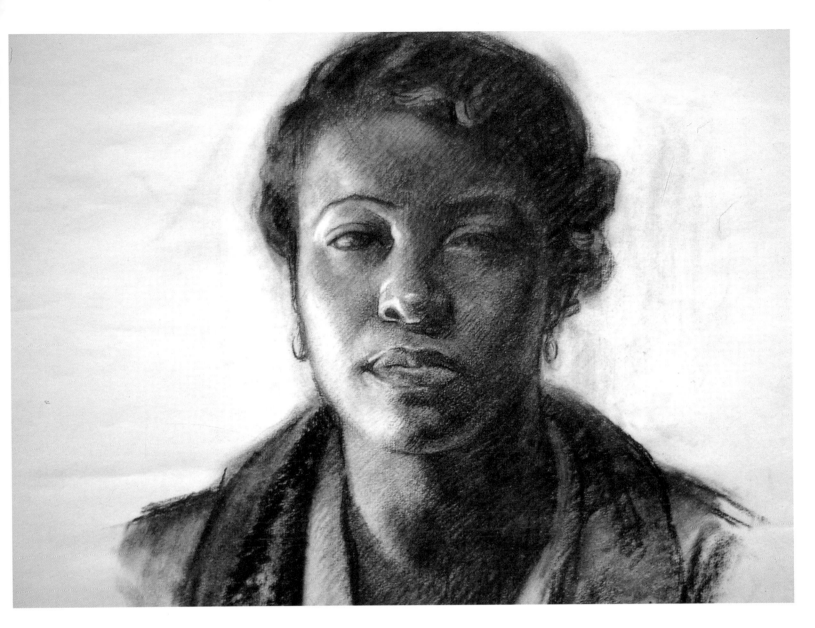

GIOVANNI MARTINO

Jessica

18" × 24" (46 cm × 61 cm)

Charcoal on paper

The artist added deep shadows to add a subtle drama to this exquisite portrait sketch.

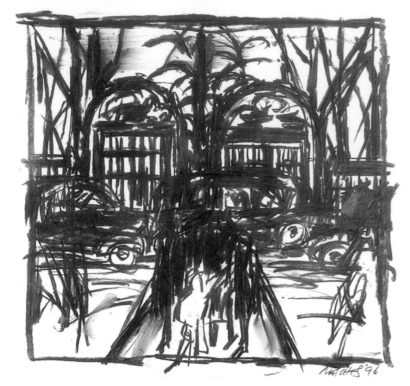

ARNOLD MESCHES

Study 1 for The Gate

15½" × 17" (39 cm × 43 cm)

Charcoal on paper

This preparatory study was included in an exhibition that commemorated the life of the artist's mother in paintings and drawings created over four decades. In the wall text that was included in the exhibition, Mesches writes, "I was half way into a painting called *The Gate*, when the nursing home called and told me that my mother 'expired.' It was almost prophetic.... What prompted me to paint a childhood memory, a snow scene, a hearse, with me surrounded by the three most important women of my childhood, my mom and my two aunts, Gustie and Sadie, I can only guess...."

ROBERT COTTINGHAM

X

11¾" × 8" (29.5 cm × 20 cm)

Graphite on vellum

This is one of twenty-six drawings from a series entitled An American Alphabet, in which Cottingham depicts letters from movie and theater marquees, as well as store signs. For the artist, it is a place where language and architecture come together.

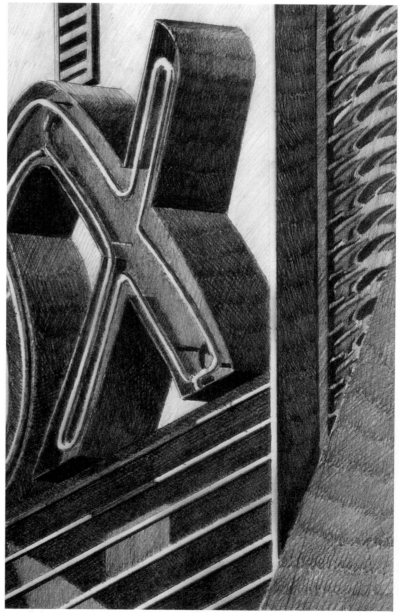

Untitled #3

27⅝" × 15⅝" (70 cm × 39.5 cm)

Graphite on paper

In this multi-paneled drawing, Ruane sets up a relationship between the three scenes, yet the connection is not clear. In the top panel, there is a flower. In the second panel, a woman holds a handkerchief on her head. In the third, the woman has let the cloth cover most of her face. In this last panel there is also a reference to the painting *Portrait of a Lady* by the fifteenth-century painter Rogier Van Der Weyden (1400–1464). However, the unifying element throughout the panels is the venetian blinds.

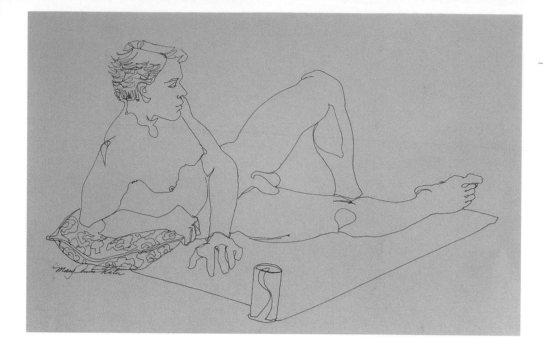

MARY ANN CHATER

Jason

9" × 12" (23 cm × 30 cm)

Pen and ink on paper

The artist has kept the point of the pen on her paper—and her eyes on the model—the entire time while making this drawing. This type of sketch is called a continuous-line drawing.

JODI COHEN

Into the Timeless Rapture

11" × 8½" (28 cm × 22 cm)

Pen and ink on paper

Cohen mixes organic, symbolic, abstract, and figurative forms together to create this intricate, biomorphic design.

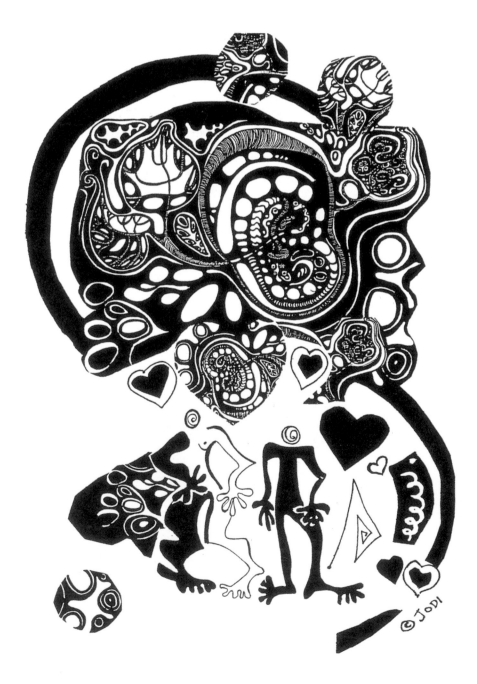

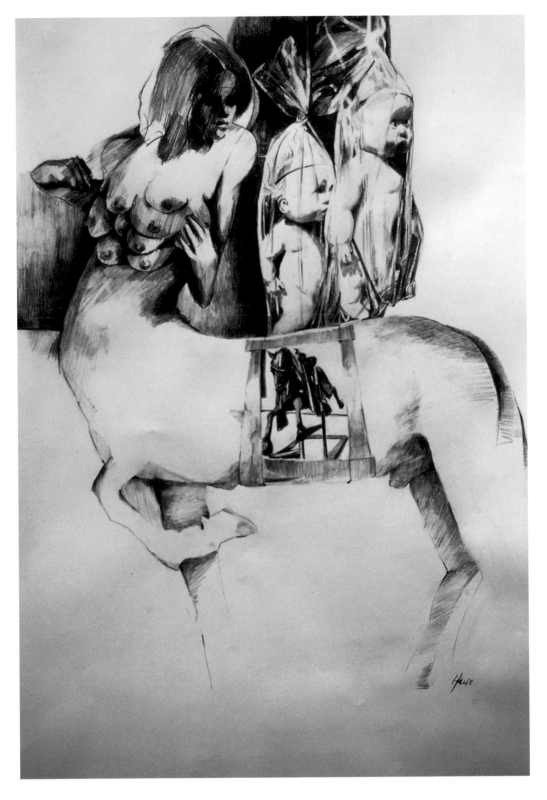

R. K. HILLIS

The Ayes of Texas

36" × 24" (91 cm × 61 cm)

Charcoal on paper

Hillis juxtaposes identifiable objects to create an ambiguous, surrealistic image.

TONY SALADINO

Derivative Shapes

17½" × 27½" (44 cm × 70 cm)

Pen and ink, pencil, charcoal, and collage on paper

Saladino overlaps and combines different mediums together to make a statement on the similarities of shapes.

WILLIAM WOODWARD

Study for The Great Odyssey of Medicine

81" × 81" (206 cm × 206 cm)

Charcoal and sanguine conté on Canson Mi-Tientes

This study, which was part of a mural that traces the history of medicine, features a reference to the prints of Andreas Vesalius (1514–1564), a Flemish anatomist who challenged traditional theories of anatomy.

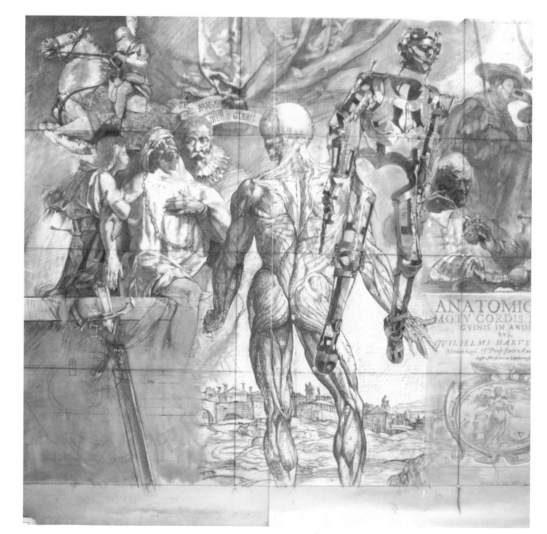

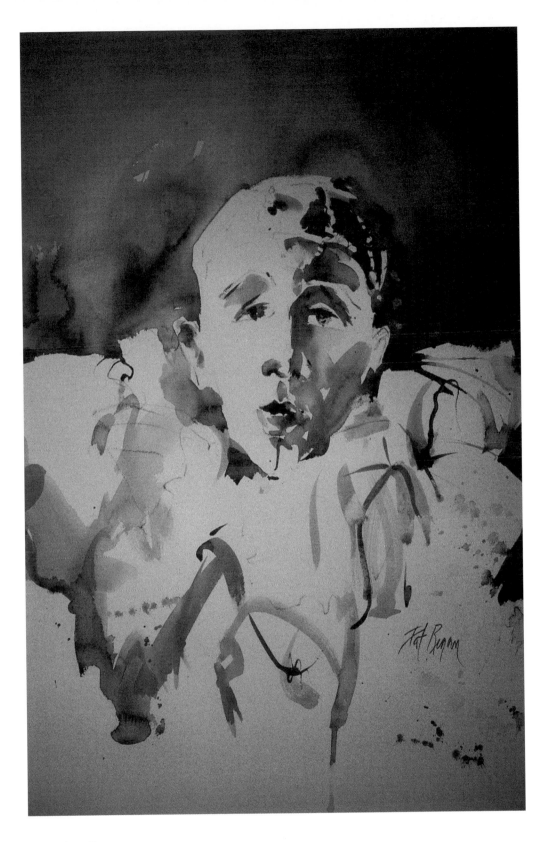

PAT REGAN

Pagliacci

30" × 22" (76 cm × 56 cm)

Watercolor on paper

For Regan, drawing with a watercolor
brush on paper allows her to loosen
up in her work.

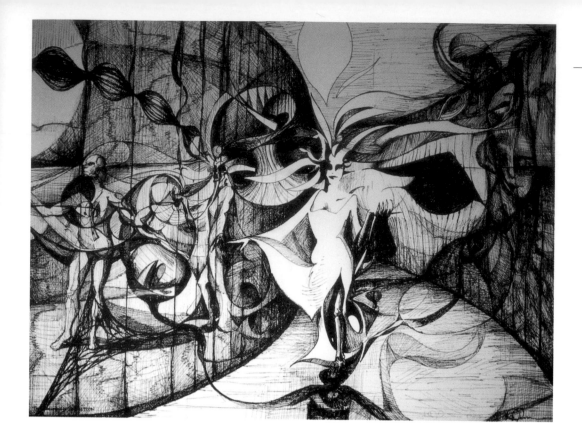

ERIK JOHNSON

Seduction of Perception

22" × 30" (56 cm × 76 cm)

Pen and ink on watercolor paper

The artist interchanges positive and negative shapes while at the same time distorting the perspective. The result is a fantastic, dreamlike image.

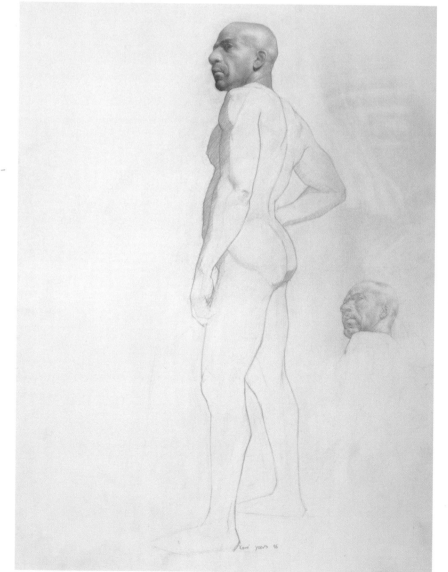

KORÉ YOORS

Nude

24" × 18" (61 cm × 46 cm)

Pencil on paper

ABOUT THE AUTHOR

Terry Sullivan is the associate editor of *Photo District News* and the former associate editor of *American Artist* magazine. He has an MA in Painting, a BA in Fine Arts and English, and has taught art and art history at St. John's University and the Art League of Long Island. His oil paintings and pastels have appeared in several exhibitions, including The Heckscher Museum in Huntington, NY, and the New York State Museum in Albany, NY. Sullivan has also demonstrated various drawing techniques on the Discovery Channel Cable Television show, Home Matters. He is represented by Art Students Showcase in New York City.

GLOSSARY

ABSTRACTION: Nonrepresentational; having little or no relationship to the appearance of actual or imaginary objects.

CARBON PENCIL: A drawing pencil made with lampblack or another carbon pigment instead of graphite.

CARICATURE: A portrait where the subject's characteristic features are exaggerated for satiric or humorous purposes.

CHARCOAL: A black crayon made of charred twigs of wood, usually willow, or pieces of vine. It is available in various degrees of hardness and thickness. It can be used as a drawing tool or as a preliminary material for oil painting. Like pastel, it easily smudges. To prevent this from happening, many artists spray a fixative over their finished charcoal drawings.

CHIAROSCURO: This term is used to describe a technique in which rigorous light and dark contrast is the principle element of expression. The technique was introduced during the Renaissance and is effective in creating an illusion of depth and space around the principal figures. The work of Caravaggio or Rembrandt are some exceptional examples of this technique.

COLD-PRESSED PAPER: This term refers to the surface quality of a particular paper. This type of paper is often more textured and rougher than hot-pressed paper. Other terms for this type of paper include dull, egg shell, matte, or simply "not."

COMPOSITION: The combination of elements in a painting or drawing so that they seem satisfactory to the artists.

CONTOUR DRAWING: The outline that defines a particular form. It is distinct from an outline drawing in that an outline drawing is more of a diagram or silhouette. A contour drawing has a three-dimensional quality that indicates thickness as well as length and width.

GESTURAL SKETCH: In figure drawing, a quick, energetic drawing that attempts to capture the essential elements of a model's pose.

GHOST MARKS: These are the not-quite-completely erased marks of charcoal or graphite left on a drawing. It is similar to pentimento in painting.

GOLDEN SECTION: A traditional proportion that is supposed to express the secret of visual harmony. In its simplest form it consists of a line divided into two so that the smaller part is to the larger as the larger is to the whole. This ratio works out roughly to be 1:1.6.

HEIGHTENING: This term is used when an artist applies white or other light-valued colors to a drawing to add depth to the range of values.

HOT-PRESSED PAPER: This term also refers to the surface quality of a particular paper. This type of paper is often smoother and less textured than cold-pressed. HP papers are also referred to as having a plate or glazed finish.

LINE: A mark made by an implement as it is drawn across a surface. It is one of the primary elements of design. An artist may build up a work of art by using straight or curved, thick or thin, light or dark, or vertical, horizontal, or diagonal lines.

NEGATIVE SPACE: The space surrounding a positive shape or solid.

POSITIVE SHAPE: An object that serves as the subject of a drawing, as distinguished from the background or the negative space.

PRELIMINARY DRAWING: A type of drawing that is either a study for a painting, which is transferred onto the canvas or ground, or one that is drawn directly on the ground. This type of drawing can help determine the structure of a composition.

PROFILE: A depiction of a person's face as seen from the side.

PULL-OFF TECHNIQUE: This is a technique mostly associated with oil painting, but it can also be used with charcoal or graphite. To use this technique, you lay down an even-toned area of charcoal or graphite and then erase the tone to create your lighter tones and highlights.

RAG: In the past, this material was the principal material used in making paper. In referring to paper, rag content describes the amount of cotton fiber in relation to the whole amount of material used in the paper pulp.

REPRESENTATIONAL: A realistic graphic depiction of recognizable objects.

SCRATCHBOARD: A specially coated white drawing ground that is covered with black ink and used to create white-line-on-black drawings.

SHAPE: Defined as a two-dimensional enclosed space. Ways of defining shape is through contour drawings, manipulating negative and positive space, overlapping rectilinear forms to create depth, and using curvilinear shape to suggest both depth and movement.

SFUMATO: In painting or drawing, transitions from light to dark that are so gradual as to be almost imperceptible. Introduced in the Renaissance by Leonardo da Vinci.

SKETCH: A rough preliminary version of a composition. This type of preliminary drawing is often rapidly executed, yet is able to present the essential characteristics of an idea or thought.

TEXTURE: Refers to the surface qualities of an artwork.

TONE: The prevailing hue in a picture or its comparative brightness or dullness.

TROMPE L'OEIL: A type of painting or drawing, usually a still life, which persuades the viewer that he is looking at the actual objects and not a piece of artwork. The artist uses various illusionistic devices to achieve this effect.

VALUE: Refers to the gradation of tone from light to dark—whether of a color or from white to black.

WASH: An application of diluted watercolor or ink to paper. The term usually refers to a broad, uniform area of tone.

WEIGHT OF A LINE: Thick and thin lines can be used in drawing to define overlapping shapes or to convey the essence of a form without resorting to modeling or shading. This can create a sense of weight.

DIRECTORY

- A -

SIGMUND ABELES
630 Ninth Ave., #102A,
New York, NY 10036

DARRYL P. ALELLO
218 Tate Rd.,
Denham Springs, LA
70726

MERWIN ALTFELD
18426 Wakecrest Drive,
Malibu, CA 90265

JUDY ANDERSON
3644 Langhorst Ct.,
Cincinnati, OH
45236-1548

GRETA AUFHAUSER
33018 Pacific Coast
Highway,
Malibu, CA 90265

- B -

ANNE BAGBY
242 Shadowbrook,
Winchester, TN 37398

RITA BARAGONA
68 Delaware Rd.,
Columbia, NJ 07832

WILL BARNET
15 Gramercy Park,
New York, NY 10003

BASCOVE
319 East 50th St.,
New York, NY 10022

DONNA BASILE
Box 97,
Scituate, MA 02066

MILES G. BATT
301 Riverland Rd.,
Fort Lauderdale, FL 33312

VIOLET BAXTER
41 Union Square
West #402,
New York, NY 10003

PAT BERGER
2648 Anchor Ave.,
Los Angeles, CA 90064

GEORGE BOBRITZKY
92 Cassilis Ave.,
Bronxville, NY 10708

BETTY M. BOWES
301 McClenaghan Mill Rd.,
Wynnewood, PA 19096

MARY ALICE BRAUKMAN
636 Nineteenth Ave., NE
St. Petersburg, FL
33704-4616

PATRICIA BROWN
815 Runningwood Circle,
Mountain View, CA 94040

MATTHEW BUCKNER
63 First Place #3,
Brooklyn, NY 11231

W. CARL BURGER
239 Beacon Light Rd.,
Califon, NJ 07830-9605

FLEUR BYERS
36 Drexel Place,
New Cumberland, PA
17070-2202

- C -

FOSTER CADDELL
47 Pendleton Hill Rd.,
Voluntown, CT 06384

JOHN T. CASEY
2095 Oak Grove Rd., NW,
Salem, OR 97304

JUDY CASSAB
16/c Ocean Ave.,
Double Bay,
Sydney, Australia 2028

MICHAEL EDWARD CELLAN
2415 Tremont St.,
Colorado Springs, CO
80907

MARY ANN CHATER
84 Sherwood Drive,
Westlake Village, CA
91361

MARGE CHAVOOSHIAN
222 Morningside Drive,
Trenton, NJ 08618

AMY CHUN
3515 Standish Ct.,
Fairfield, CA 94533

MARY CLOSE
129 East 82nd St., Apt. 7C,
New York, NY 10028

RUTH COCKLIN
5923 South Willow Way,
Greenwood Village, CO
80111

JODI COHEN
322 West 104th St., New
York, NY 10025

DEDE COOVER
300 Twin Oaks Rd.,
Cameron Park, CA 95682

JOSEPH CORREALE JR.
25 Dock Square,
Rockport, MA 01966

ROBERT COTTINGHAM
P.O. Box 604,
Newtown, CT 06470

SUSAN COTTLE
1641 First Ave., Apt. 3C,
New York, NY 10028

DOMENIC CRETARA
5353 East Flagstone St.,
Long Beach, CA 90808

JANE CULP
459 West Broadway,
New York, NY 10012

- D -

PHYLLIS A. DE SIO
541 Revere Ave.,
Westmont, IL 60559

JOHN J. DE SOTO
369 Boxwood Drive,
Shirley, NY 11967

DOUGLAS DIBBLE
356 Union St., #6,
Brooklyn, NY 11231

SHARON DiGIACINTO
6741 West Cholla St.,
Peona, AZ 85345

EDWIN DOUGLAS
31 Gertrude Ave.,
Portland, ME 04103

- E -

BENJAMIN EISENSTAT
3639 Bryant St.,
Palo Alto, CA 94306

JOHN T. ELLIOT
304 Highmount Terrace,
Upper Nyack, NY 10960

RUTH L. ERLICH
161 Tigertail Rd.,
Los Angeles, CA
90049-2705

ROB EVANS
7152 Roundto Lane,
Wrightsville, PA 17368

JOHN EVELEIGH
4 Broadfield Rd.,
Folkestone, Kent, England
CT20 2JT

- F -

BRAD FAEGRE
120 East La Habra Blvd.,
Ste. 103-B,
La Habra, CA 90631

LOUIS FINKELSTEIN
459 West Broadway,
New York, NY 10012

STEPHEN FISHER
163 Exchange St., #404,
Pawtucket, RI 02860

MICHAEL FRARY
3409 Spanish Oak Drive,
Austin, TX 78731

KAREN FREY
1781 Brandon St.,
Oakland, CA 94611

BARBARA FUGATE
8748 17th NW,
Seattle, WA 98117

- G -

DAN GHENO
320 West 56th St., #34,
New York, NY 10019

NELLIE GILL
318 Madrid Drive,
Universal City, TX
78148-3143

ROBERT GIRANDOLA
1746 Quarry Rd.,
Yardley, PA 19067

HAROLD L. GREGOR
107 West Market St.,
Bloomington, IL 61701

JOSEPH E. GREY II
19100 Beverly Rd.,
Beverly Hills, MI
48025-3901

CYNTHIA GRILLI
505 Court St., #6N,
Brooklyn, NY 11231

MICHAEL A. GRIMALDI
P.O. Box 202,
Mt. Tremper, NY 12457

- H -

ALBERT HANDELL
P.O. Box 9070,
Santa Fe, NM 87501

PAMELA WALKER HART
7018 Stokes
Westernville Rd.,
Ava, NY 13303

JEFFREY HAYMAN
162 East 33rd St., #2,
New York, NY 10016

MARYBETH HEIKES
R.R. 3,
Centerville, IW 52544

KATHERYN S. HEUZEY
121 Lawrence Hill Rd.,
Cold Spring Harbor, NY
11724

ANNE HEYWOOD
85 Ashley Drive,
E. Bridgewater, MA 02333

R. K. HILLIS
6741 West Chola,
Peoria, AZ 85345

SERGE HOLLERBACH
304 West 75th St.,
New York, NY
10023-1609

JAMES HOSTON
420 Clinton Ave., 2H,
Brooklyn, NY 11238

FRANCES HYNES
35-41 205th St.,
Bayside, NY 11361

- I -

T. F. INSALACO
270 Gorham St.,
Canandaigua, NY 14424

- J -

DALE JARRETT
6032 West 50th St.,
Mission, KS 66202

BARBARA JOHNSON
25 West St.,
Hadley, MA 01035

ERIC JOHNSON
P.O. Box 1755 #150
Nederland, CO 80466

DIANE ELIZABETH JONES
420 Clinton Avenue #2H
Brooklyn, NY 11238

- K -

WOLF KAHN
217 West 21st St.,
New York, NY 10011

CAROL KARDON
248 Beech Hill Rd.,
Wynnewood, PA 19096

MICHAEL KAREKEN
3215 Humbolt Ave.,
South, Minneapolis, MN
55408

ATANAS KARPELES
2033 East Casa Grande St.,
Pasadena, CA 91104

JAY KELLY
4-74 48th Ave., Long
Island City, NY 11101

RACHEL KENNEDY
680 Wood Shine Lane,
H-10, Naples, FL 34105

EVERETT RAYMOND KINSTLER
15 Gramercy Park South,
New York, NY 10003

JUDITH KLAUSENSTOCK
94 Reed Ranch Rd.,
Tiburon, CA 94920

GREGORY KONDOS
1523 7th Ave.,
Sacramento, CA 95818

- L -

ROBERT LAMELL
2640 Wilshire Blvd., West,
Oklahoma City, OK 73116

DEBORAH NIETO LEBER
221 Orchard St.,
Cranford, NJ 07016

DAVE LEBOW
27351 Palo Verde Pl.,
Apt. 204,
Canyon Country, CA
91351

DOUGLAS LEW
4382 Browndale Ave.,
Edina, MN 55424

PORTER A. LEWIS
3845 35th W,
Seattle, WA 98199

STANLEY LEWIS
3117 South Dakota Ave.,
NE, Washington, DC
80018

WILLIAM LEWIS
1421 Garfield St.,
Boise, ID 83706

KYLE LIND
c/o The Municipal Art
Gallery, Barnsdall Art Park,
4808 Hollywood Blvd.,
Los Angeles, CA 90027

THOMAS P. LOEPP
110 Clifton Place, Apt. 4C,
Brooklyn, NY 11238

ROBERT LONGO
224 Centre Street, 6th
Floor, New York, NY
10013

JOE HING LOWE
36 Greaves St.,
Cranford, NJ 07016

BETTY LYNCH
1500 Harvard,
Midland, TX 79701

- M -

JILL MACKIE
24 Grove St.,
Narrowsborg, NY 12764

ILONA MALKA
163 Charles St.,
New York, NY 10014

GIOVANNI MARTINO
1435 Manor Lane,
Blue Bell, PA 19422

PAUL W. MCCORMACK
P.O. Box 537,
Glenham, NY 12527

ALEX MCKIBBIN
3726 Pamajera Drive,
Oxford, OH 45056

ARNOLD MESCHES
254 East 7th St.,
#15-16,
New York, NY 10009

DEAN MITCHELL
11918 England,
Overland Park, KS 66213

MARY T. MONGE
78 Allenwood Lane,
Aliso Viejo, CA 92656

- N -

NORMAN NEASOM
95 Bromfield Rd.,
B 974 PN, Redditch,
Worchestershire, England

- O -

BEA JAE O'BRIEN
34 Sea Pines,
Moraga, CA 94556

SUSAN OGILVIE
P.O. Box 59,
Hadlock, WA 98339

NANCY OHANIAN
139 Kings Highway East,
2nd Floor,
Haddonfield, NJ 08033

PATRICK O'KIERSEY
3240 Telegraph Ave.,
Oakland, CA 94609

- P -

WILLIAM PFAFF
5417 Courtland Rd.,
Spring Field, TX 37172

ALEXANDER C. PICCIRILLO
26 Vine St.,
Nutley, NJ 07110-2636

RUTH PLATNER
2503 Via Astuto,
Carlsbad, CA

ALEX POWERS
401-72nd Ave., North,
Apt. 1,
Myrtle Beach, SC 29577

- R -

KATHERINE REAVES
163 Exchange St., #404,
Pawtucket, RI 02860

PAT REGAN
120 West Brainard St.,
Pensacola, FL 32501

DONALD RESNICK
15 Revere St.,
Rockville Centre, NY
11570

DENNIS REVITZKY
131 Monroe St.,
Honeoye Falls, NY 14472

JUNKO ONO ROTHWELL
3625 Woodstream Circle,
Atlanta, GA 30319

KAY RUANE
4325 Xerxes Ave.,
Minneapolis, MN 55410

LOIS J. RYDER
Box 35A, SR 62,
Great Barrington, MA
01230

- S -

TONY SALADINO
756 Norwood,
Hurst, TX 76053

NICHOLAS SCALISE
59 Susan Lane,
Meriden, CT 06450

R. SCHOFIELD
P.O. Box 10561,
Tampa, FL 33679

PETER SELTZER
87 Main St., North,
Woodbury, CT 06798

JOSEPH SHEPPARD
3908 N. Charles St.,
Apt. 1200,
Baltimore, MD 21218

JO SHERWOOD
1401 Camino Cruz Blanca,
Santa Fe, NM 87501

MORRIS SHUBIN
313 North 12th St.,
Montebello, CA 90640

RUTH SKLAR
14569 Benefit St., #106,
Sherman Oaks, CA
91403-3749

EDITH SOCOLOW
26 Salt Island Rd.,
Gloucester, MA 01930

DONNA STALLARD
413 South O'Conner,
Irving, TX 75060

PENNY STEWART
6860 Cedar Ridge Ct.,
Colorado Springs, CO
80919

TIMOTHY STOTZ
41 Lincoln Rd.,
Brooklyn, NY 11214

JANE SUTHERLAND
131 Colonial Drive,
Fairfield, CT 06430

ANDY SYRBICK
27 Clinton St.,
Framingham, MA 01702

- T -

WARREN TAYLOR
P.O. Box 50051,
Midland, TX 79710-0051

KRISTEN L. TEMPLE
175 Cutter Ave.,
Fords, NJ 08863

JAMES P. TEMPLETON
305 Pine Street, Apt. 2R,
Philadelphia, PA 19106

ROBERT C. THERIEN JR.
1015 North Somers Ave.,
Fremont, NE 68025-3911

NEDRA TORNAY
2131 Salt Air Drive,
Santa Ana, CA 92705

SUSAN WEBB TREGAY
470 Berryman,
Snyder, NY 14226

BONESE COLLINS TURNER
4808 Larkwood Ave.,
Woodland Hills, CA 91364

- V -

JAMES VANCE
R.R. 1, Box 165A,
Carmel, CA 93923-9803

TED VAUGHT
1527 NE Hancock St.,
Portland, OR 97212

- W -

LAWRENCE WALLIN
895 Toro Canyon Rd.,
Santa Barbara, CA 93108

GUY WARREN
118 River Rd.,
Greenwich, NSW, 2065
Australia

JERRY WEISS
30 South Wig Hill,
Chester, CT 06412

ANITA LOUISE WEST
223 North Guadalupe
#179, Santa Fe, NM 87501

KIRSTEN WESTPHAL
356 Union St., #6,
Brooklyn, NY 11231

MICHAEL WHITTLESEA
Richmond Cottage, High
St., Hurley, Berkshire
SL6 5LT, England

CHRISTOPHER WILLARD
407 West 54th St., 3E,
New York, NY 10019

EDWARD L. WILLIMON
111 South Royal
Oak Drive,
Duncanville, TX
75116-4227

CRYSTAL WOODWARD
24 Kenmore Rd.,
Belmont, MA 02178

EUDOXIA WOODWARD
24 Kenmore Rd.,
Belmont, MA 02178

WILLIAM WOODWARD
8421 Meetze Rd.,
Warrenton, VA 20186

MARK WORKMAN
1165 Pine Hill Rd.,
Lititz, PA 17543

- Y -

RHODA YANOW
12 Korwell Circle,
West Orange, NJ 07052

KORÉ YOORS
108 Waverly Place,
New York, NY 10011

INDEX